Stealing the Mona Lisa

Stealing the Mona Lisa

Stealing the Mona Lisa

What art stops us from seeing

DARIAN LEADER

Shoemaker & Hoard
Washington, D.C.

First published in the UK by Faber and Faber Limited
First paperback edition by Shoemaker & Hoard in 2004

Libraryof Congress Cataloging-in-Publication Data is available.

ISBN 1-59376-039-6

Shoemaker & Hoard
A Division of Avalon Publshing Group Inc.
Distributed by Publishers Group West

10 9 8 7 6 5 4 3 2 1

For Sarah Elizabeth

CONTENTS

ACKNOWLEDGEMENTS

This book grew out of a series of invitations to talk about psychoanalysis and art. For his stimulus, interest and criticism, I would like to thank Olivier Richon, as well as the art schools that have invited me to lecture over the years, especially the Royal College of Art, whose students have helped me to rethink many of the ideas that follow. Pat Blackett, Sophie Luard and Anna Selander gave me invaluable assistance with research, and I owe a great deal to the kind and various contributions of Parveen Adams, Maria Alvarez, Karen Ashton, Henry Bond, Norman Bryson, Bernard Burgoyne, Matt Collings, Sadie Coles, Angus Cook, Bronwyn Cosgrave, Vincent Dachy, Erica Davies, Beverley Eddy, Mette Houlberg, Franz Kaltenbeck, Honey Luard, Joanna Mackle, Simone Meentzen, Gretel Mitchell, Geneviève Morel, Joseph O'Neill, Carlo Pedretti, Renata Salecl, Annushka Shani, Jeroen Stumpel, Emily Tsingou, Natasha Walter, Lindsay Watson, Esther Windsor and Rupert Wyatt, as well as to the family of Ruth Weber and my colleagues at the Centre for Freudian Analysis and Research in London. Julian Loose at Faber was his usual patient and supportive editorial self and Georgina Capel at Capel–Land was as ever the perfect agent. I am very grateful to the artists and galleries who have allowed me to reproduce works in the pages to follow – and in particular to one of them, who is more to me than an artist, while never being anything less.

This contemporary cartoon clothes the thief in an outfit that would later come to characterize not the criminal but his nemesis, the Clouseau-like detective.

STEALING THE MONA LISA

On the morning of 21 August 1911, a slight, white-smocked man slipped out of one of the side entrances of the Louvre, and soon vanished into the crowds on the rue de Rivoli. His step was not easy, as beneath his smock he held a wooden panel which he had both to conceal and protect. When he arrived back at his small and sparsely furnished room on the rue Hôpital Saint-Louis, he slid the panel carefully into a recess, hidden from view by piles of firewood. Soon, it would be fitted snugly into the false bottom of a trunk which had been specially built to match the panel's dimensions. No one raised an eyebrow when Vincenzo Peruggia turned up at work two hours late. How were they to know, after all, that this quiet, discreet house painter had just stolen one of the world's most famous works of art?

The theft itself was equally quiet and discreet: the *Mona Lisa*'s absence was noticed only some twenty-four hours later. The 21st was a Monday, then the Louvre's weekly closing day, and works had a habit of disappearing into an annexe to be photographed. A mason who glanced at the picture around 7 a.m. while passing through the Salon Carré noted that it was no longer there an hour later, but interpreted its absence as a sign of security: 'Well, well,' he said to his colleagues. 'They're afraid somebody's going to pinch it.'

The next day, the Louvre had become like police head-quarters. More than sixty detectives and policemen searched

the rooms and corridors for clues. Officials and staff returned from their summer holidays to the scene of the crime. Press conferences were convened and the front pages spoke of little else. It was impossible to escape the image of the kidnapped lady. There she was on newsreels, chocolate boxes, postcards and billboards. Her iconic fame was suddenly transformed into the celebrity of filmstars and singers. Crowds gathered at the Louvre to gaze at the empty space where the picture had once hung. Many of these excited spectators, it turned out, had never been to the Louvre, or indeed seen the picture before.

When Franz Kafka and his friend Max Brod arrived in Paris three weeks after the theft, they lost no time in joining the queues to see the empty space. As Brod noted in his journal, the *Mona Lisa*'s image was everywhere, and even a trip to the cinema offered little respite, with a spoof film about the robbery coming on after a lively silent comedy. The image had succeeded in saturating culture in all its media. But what could explain this abundance of images? And why go to stare at an empty space? What was it exactly that Kafka and Brod expected to see?

Perhaps the story of the *Mona Lisa*'s disappearance can tell us something about art and why we look at it. When the Royal Academy in London hosted a vast Monet exhibition a few years ago, the press took much delight in showing us the thousands of people who camped and queued to access the world of the French painter. The television reports didn't seem that interested in the show itself, but the congregation of such a significant percentage of the British population was a phenomenon. The cynics who compared the hordes of fatigued art lovers to sheep missed the point. What the Royal Academy had staged was not a Monet retrospective

but an installation piece composed of the multitudes who had no idea that they were the subject of a work of art. The flower paintings were just bait. The installation was asking them the questions: What were they doing there? What did they expect to find?

Several works of art in the last few decades have in fact had as their object the assembly of a large group of people who think they are there for some other reason. When they realize that there is no other reason, they can start thinking about what they are really doing. Did the London crowds flock to see the Monet exhibition simply because it was there? Or was there something specific, individual and singular in the paintings that each viewer was looking for? Maybe it was both. But how, then, can we explain that other great group phenomenon of twentieth-century art, the convergence of legions of French men, women and children on the Louvre to see not a painting but the absence of a painting? It was the empty space left by the vanished *Mona Lisa* that the crowds flocked to see. It was less a case of going to see a work of art because it was there, than, on the contrary, because it wasn't there.

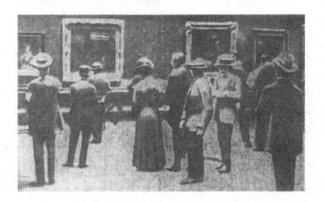

A bank robbery does not result in the bank becoming a tourist attraction, and it would be difficult to imagine an invasion of the Tower of London by a populace eager to see the absence of the Crown Jewels after some ingenious burglary. Would this happen only if the purloined object were a work of art? And would the work of art in question have to have achieved an unparalleled fame? It is true that the *Mona Lisa* is not so much a painting as the symbol of painting itself. That's why it has been a perpetual target for cartoonists and anyone with an axe to grind about classical art. To evoke classical art or accepted, socially sanctioned art, how could one do better than to summon up the image of Leonardo's painting?

This is the most frequently reproduced work in the history of painting. It has spawned an industry of copies, in the form of posters, brooches, mugs, T-shirts, cigarette cases, lighters, scarves and all manner of other objects, as well as an industry of spin-offs, from the use of the Florentine lady's image in cartoons to its appropriation by artists, from Marcel Duchamp to Andy Warhol and beyond. When Warhol juxtaposed thirty images of the *Mona Lisa* in his piece *Thirty are better than one*, his choice reflected the painting's strange propensity to multiply itself. Even the man who stole the *Mona Lisa* and kept it sequestered in his single room for over two years felt compelled to display postcard reproductions of the work on his mantelpiece.

The painting's reproductive success gives the original a peculiar status. As the 'real thing', the final referent of innumerable copies and versions, it takes on the character of a mythic, lost object. And yet, before its theft, this was hardly the case. In the nineteenth century, it was Raphael's *Fornarina* that enjoyed pride of place as a key artistic icon,

to be followed by the cult of his Sistine *Madonna*. The *Mona Lisa* was cherished, but its elevation would be permanently established only by its disappearance. It had to vanish to become a symbol, and the surreal photographs of the huge, traffic-stopping crowds thronging to catch a glimpse of it when it toured other countries in the 1960s and 1970s testify to the uncanny quality that touches Leonardo's painting.

On its brief visit to the National Gallery in Washington in 1963, 674,000 people went to have a look, a figure that represented more than half the gallery's usual attendance for a whole year. The opening hours had to be extended for the first time ever. At the Metropolitan in New York, it received more than one million viewers in less than a month. The millionth, a Mr Arthur Pomerantz of New Rochelle, was given a reproduction of the painting, and his two daughters each received special booklets. Such phenomena might invite one to see in the *Mona Lisa*'s reception a metaphor for human desire: a vast congregation of people searching for a tiny object that offers some unspoken, enigmatic promise. And yet, the encounter with an empirical object that has taken on such symbolic power can result only, perhaps, in disappointment. If Leonid Brezhnev saw no more in the picture than 'a plain, sensible-looking woman', one American viewer would comment, with a frown, 'Why, it's no bigger than a 21-inch television screen.'

Such disappointments might tempt one to try to restitute the dignity of Leonardo's masterpiece as a painting rather than as a symbol. One could point to previously unexplored aspects of the brushwork or iconography, but, with the weight of the thousands, perhaps millions, of hours of the sustained concentration of previous scholars, this venture might bear no fruit other than its own labour. Although it is perfectly

possible for some new fact or insight to be born from the pangs of such research, one's sympathy for the discouraged scholar can be only heartfelt. Robbery, in fact, seems the better option. If the *Mona Lisa* is gone and then comes back, we might appreciate it in a new way, just as in so many love stories we start to love our partner again only once we've lost and then refound them. If the *Mona Lisa* gained its iconic status from being lost and then refound, would another disappearance give it a new and different value?

Art theft today is a burgeoning enterprise. For each reported incident, there is supposedly at least one unreported crime, with an annual increase of around 10 per cent. And with a detection rate of slightly less than this figure, the prospects of an art thief might not seem unattractive. The pursuit of the *Mona Lisa* was certainly a bungled operation, and we will suggest later some possible reasons for the amazing series of police blunders that prevented its recovery. The painting's habit of cloning itself in reproductions and copies is also instructive here, as we learn from the legal authorities that it is better to steal pictures that are similar to others.

The Victorian artist John Frederick Herring painted thousands of farmyard scenes that are all more or less to a formula. Discussing the legal aspects of art theft, one expert pointed out that if a dispossessed owner were to view three of Herring's works in a police line-up, they wouldn't be able to tell which one was theirs. And similarly, if a police raid were to reveal a cache of Herring's paintings, and three of them could be linked to three owners, how could each particular painting be allocated to a particular owner? This situation would become even more farcical if the thief turned out to be a collector of Herring's works and hence the

legitimate owner of at least some of the paintings in the cache.

Art theft no doubt raises a number of legal and philosophical problems, but what are the emotional, subjective effects of an object's disappearance? Most things become more interesting once we've lost them. We can start looking for them, and then, perhaps, realize their true value. Civilization actually manufactures certain objects – such as the umbrella and the handkerchief – whose main function is to be lost. Shrinks, whose umbrella collections are continually growing, would say that actually things are a bit more complicated here. We don't realize the true value of a handkerchief once we've lost it, but it attains this value only *because* we've lost it. We value it, perhaps, because it isn't there. This might be because even an apparently trivial loss has the power to evoke the major, painful losses of our childhood. But more on this later.

If it's true that we start looking for things once we've lost them, might this give us a clue as to why we look at visual art? Are we looking for something that we have lost? And if so, what might this something be? Psychoanalysis has had quite a lot to say about these questions, and often in reference to the *Mona Lisa* itself. Is her famous smile, for example, Leonardo's attempt to re-create the lost smile of his beloved mother? This is what Freud argues in his book about Leonardo, published in May of 1910, suspiciously close to the date of the painting's actual theft just over a year later. And yet if Freud was right, the art historian can reply, 'So what?' Psychoanalysis and art have never made the best of bedfellows. The many painful attempts to explain the genesis and composition of a work of art through appeals to the biography of the artist tend to be dismissed as reductive and

unhelpful. Do we really care, after all, if Picasso lived through a medium-scale earthquake as a child or that the infant Frank Lloyd Wright was devoted to his wooden building blocks?

But psychoanalysis and art can still spend time together. Psychoanalysis might be able to tell us something about why we look, and art can jog shrinks into rethinking their ideas and dogmas. It is significant that when Freud turns to consider works of art, it is at moments when he is stuck with a clinical problem. His little book about Leonardo contains his first formulations of several important psychoanalytic concepts, as if he needed the encounter with the artist to get things moving. Although Freud has been much maligned for his efforts here, we will see how his work still has much to offer, as does the work of Lacan on art and vision, which is now becoming unfashionable in the areas of art theory that once embraced it.

The many references to Lacan that follow might produce a yawn in art theorists, but his ideas, to my mind, are still exciting enough to make psychoanalytic perspectives on art worthwhile. As well as having been Picasso's doctor, Lacan was an early contributor to the Surrealist review *Minotaure* and enjoyed an extended theoretical exchange with Salvador Dali, who remained a lifelong friend. His work continually returns to problems in aesthetics and the theory of art, and has provided an inspiration not only to art historians but also to many artists. Despite this, there are dangers of mixing psychoanalysis and art. Since artists tend to have late nights, the learning experience for the psychoanalyst may result in fatigue and weariness. Likewise, the avoidance of narcotics and excessive drinking may make the psychoanalyst appear dull and devitalized.

A further word of caution. Books about art often contain

sweeping generalizations, and it is usually not too difficult to come up with counter-examples to any given theory. I have tried to qualify many of the generalizations in what follows, yet it may still be useful to read the term *art* as referring to *some art*. Likewise, it seems to me a useful rule of thumb when reading about art to ask oneself the question of what kind of art the author is really talking about. Many statements might become clearer when we realize what that particular writer actually had on their walls or what they actually went to look at. One can be mystified at blinkered comments made about 'art' until we realize that what the author is really talking about is Cézanne or Van Gogh, for example. The point is that in many books written from outside the field of art history we aren't told.

Rather than seeing such tendencies as mere prejudice, they can in fact illuminate the odd business of interpreting art. When we come across some statement about 'painting' or 'sculpture' that seems dubious, our first reaction might be to think of a counter-example, the image of some artwork that resists the author's generalization. And yet doesn't this show how we all have a catalogue of latent images, in exactly the same sense that the author, in making a remark about 'painting', might be thinking of works by no one but Cézanne? When we read about 'art', this can never mean 'all art', due precisely to the existence of such a store of latent images. And that is one reason why theories of art never work.

Thinking about art perhaps involves just this series of frictions, where each of us produces counter-examples and refutations. In this book, I am probably thinking too much about painting, and it is for the reader to put the various claims that I make to the test.

❦

One of the big clichés in popular debates around aesthetics is to compare works of modern art to the ephemera of children. Saying 'A child could have painted this' is believed by many to invalidate a work, to show that the emperor isn't wearing any clothes. Occasionally, a child's work is actually sent in to some competition and when the age of the artist is revealed, the conceits of the art world are supposed to collapse. Constable is the patron saint of this perspective, with his dictum that 'There has never been a boy painter, nor can there be.'

Whether one chooses to interpret such remarks as a sign of ignorance or of understanding, they overlook the significance of the relation between a work and the place in which the work finds itself. There might be no such thing as a boy painter, but if a boy's painting finds itself in the right place at the right time, can we deny so swiftly that it is a painting? And, equally, the appreciation of children's art *as* children's art illustrates the same tension: if a parent heaps praise on some awkward rendition of a landscape by their young child, they are assuming a difference between the object itself – the drawing – and the place that this object is supposed to occupy, defined by our expectations of what children's art should be. If a child is drawing a house, does anyone bat an eyelid if they stick on a chimney when the house, in fact, has none?

The way in which children's art is received and interpreted can tell us a lot: not only about the psychology of a parent but about the more general question of how a society sanctions the production of visual images. And this, in turn, might tell us something about the forces at play in our relation to visual art.

Psychologists have devised many tests based on children's rendering of the human body. In some of them, the subject

will score additional points for each extra detail of the body: eyebrows, fingers, ears and so on. They will lose points for such deficiencies as 'no eyes', 'no mouth', 'no feet' or even 'no body'. The more the child can draw, the better. The more real details of the human body that are included, the more intelligent, adapted or well integrated is the child. But, curiously, this rule of inclusion has an exception. If the child makes his or her picture even more real, by including the genitals, they suddenly start to lose points. Hair, feet, hands and eyebrows are fine, but put in the sex and everyone starts to get worried, at least in Western culture. How can this be, that our immersion into the world of the visual image has to leave something out? An extra chimney is fine, but the sex isn't.

Freud's early ideas about scopophilia, the pleasure in looking, also revolve around this notion of an exclusion. 'The progressive concealment of the body,' he writes, 'which goes along with civilization, keeps sexual curiosity awake. This curiosity seeks to complete the sexual object by revealing its hidden parts.' Our visual curiosity is organized around something hidden. Genitals are veiled, and the visual world becomes interesting for us as we seek to complete it by searching for the concealed element. Our entry into civilization, our becoming human, for Freud, demands the exclusion of part of the body: it's both the price we pay and the condition of our pleasure in looking.

This might explain the bizarre popularity of *The Full Monty*, a film about male strippers in which we see everything apart from the penis. Lots of social realism and allusions to genitals but no genitals. If we take seriously the early idea of Freud, *The Full Monty* captivates us precisely because it is not 'the full monty'. If we compare this with the

contemporary American version of social realism, *Boogie Nights*, the effect is inverted. The audience hears all about the penis throughout the film but doesn't see it, as in *The Full Monty*, until the final shot in which it is suddenly revealed in a disturbing and unreal moment. This intrusion cancels out any possibility of the feelgood effect that characterizes the British film, and produces a strange sense of artificiality. Social realism dissolves into the surreal. Culture demands that the visual field is built up out of an exclusion from the image, and when the excluded element returns, we lose the co-ordinates that make our world real.

Is it all so simple? And don't so many works of contemporary art in fact show us the genitals without producing any sense of unreality? Louise Bourgeois might have spent some of her formative years in the 1920s working in her parents' business to excise the genitals from Renaissance tapestry, but anyone cultivating a similar aspiration today would be unlikely to find employment. What was once excluded is now commonplace. Indeed, the popular idea that sexual images had to wait until the modern era to overcome their exclusion from classical art is open to question. Leo Steinberg showed in his once controversial book on sexuality in the art of the Renaissance that Christ's penis is just about everywhere, even in a state of erection. It wasn't excluded from the image, but we somehow failed to notice it. Although in many cases the offending details were later removed, enough well-known images survive to make our blindness astonishing.

These observations do not entirely impeach the first version of Freud's argument, if we understand it in the more general sense that the world of vision captures us due to what we do not see. The excluded element does not have

to be the reality of the sex organs: perhaps there is something else that eludes visualization. What else might there be that we don't see, or even that we *cannot* see?

One much discussed example is our own act of seeing. Or, indeed, the way that we are seen by others. Just as we cannot focus on *both* our eyes in the act of seeing in a mirror, we can only imagine the way that someone else is looking at us. Although Freud and his early followers tended to privilege the feeding relation as the first erotic link to the mother, more recent research has shown the importance of the interchange of looks between baby and care-giver. Mothers can become quite anxious if the child fails to follow the direction of their gaze, and it seems likely that this is one of the archaic forms of refusal available to the infant. Turning away from the breast can be a way to show one's subjectivity, one's difference from what the care-giver wants, but equally so the turning away of one's gaze.

This suggests two things: firstly, that our look is linked dynamically to someone else's look and, secondly, that right from the start we are looked at. What we see and where we look will depend, in part, on what someone else sees and where someone else looks. At the very moment of coming into the world, before, in a sense, we can 'see' anything, we are the object of someone else's look. Infants can protest against being fed or potty-trained or educated, but how can they protest against being looked at? This fact in itself might imply that the experience of being looked at can be felt as invasive and persecutory. The psychoanalyst Otto Fenichel once pointed out that before Little Red Riding Hood told the wolf what a big mouth it had, she said, 'What big eyes you've got.' The eyes' menacing qualities are prior, perhaps, to those of the devouring mouth.

13

Refusing to follow the mother's line of sight may signal a disengagement from her demands, but it cannot make one invisible. We can avoid looking at someone else, but it is more difficult to stop them from looking at us, especially in the state of dependency that characterizes infancy and early childhood. Perhaps this explains the fantasy children often have that by shutting their eyes they become invisible to others. And doesn't this also shed light on the many games of peek-a-boo played by infants? The menacing quality of the care-giver's look is tamed and situated in a ritual that involves the rhythms of presence and absence, like the famous *Fort/Da* game discussed by Freud in which the child makes a cottonreel appear and then disappear. Where a baby might sometimes react to being looked at as if it were an almost physical intrusion, trying to move away or starting to cry, the later games of peek-a-boo turn the look into something that *isn't always there*. It can be modulated and organized, linked, by the game, to a structure. And so the potentially traumatic dimension is transformed into a source of pleasure.

Lacan had the idea that a psychoanalytic theory of vision should take as its starting point this fact that, before looking, we are looked at, and that our look is caught up in what we can call a dynamic of looks. Note how different this is from the widespread assumption that to investigate visual and aesthetic responses we should be studying what goes on when an observer looks at an object. Instead of positing two terms – the viewer and the object – we have at least three: the viewer, the object and the third party who is viewing the viewer.

The presence of this third party complicates the more traditional model, and raises a question that, as we will see,

is crucial to understanding the dynamics of vision: how can we ever know for sure what the other sees? This question certainly haunts the history of art. When many artworks ceased to be objects for the private pleasure of court and aristocracy, how could one look at a painting and not consider the look of those who had gazed there before? One's own look was linked to the look of someone else, just as in the elaborate stage sets of Renaissance court spectacle designed using the laws of perspective the only perfect viewpoint was that of the monarch. A stage with an arch, side wings and a painted backcloth was viewable in perfection from only this one point. The rank of courtiers was gauged by their proximity to him, how close they were to seeing the visual spectacle through his eyes.

What one sees with one's own eyes is mixed up with the question of what someone else sees. It is curious that this motif has been discussed much more in art theory than in developmental psychology, although Piaget cites some observations suggesting that children believed that their looks could 'mix'. We will see later how some results from psychology and from psychoanalysis linked to this question can enrich the theory of art, but for the time being we can simply note the fact that people wandering around art galleries often start thinking about how someone else would see the work they are looking at – usually, someone they love.

A recent work exploring this motif is a video piece by the Austrian artist Anita Witek. The film charts her trajectory from home to studio space as monitored by the various CCTV cameras along her route. What we see is quite literally what the CCTV has recorded. The work thus raises the usual issues of surveillance, control, Big Brother and so on. But beyond this, Witek's piece suggests that *what looks at us*

does not always see us. The cameras, after all, are oblivious to what they register: strictly speaking, they see nothing. On the contrary, it is the artist's work of appropriating and then assembling the bits of footage based on her own presence in the picture that restores to them their function as seeing.

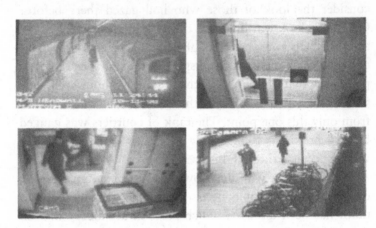

The immediate interpretation of this piece in terms of Big Brother watching us slightly misses the point. It assumes that there is an opposition between our view of ourselves and the look of others, yet in fact the look of others is built into our own self-image. Someone might spend their whole life trying to be the person they think one of their parents wanted or once loved. We see ourselves, or strive to be seen, as we imagine the other looks at us. Hence the strange effect in surreptitiously filmed documentaries, where the figures seem to be acting, artificial, as if they knew that a camera was present. And yet can we ever know, beyond supposition, how the other sees us? All that we can know for sure is that we are looked at. Witek's piece might thus be understood as the effort to put herself in the place of this other to see how it really sees her.

But the CCTV cameras do not see. Rather than attempting to see what the other sees, Witek's piece evokes the tension between an eye and the act of seeing, the split between seeing and looking. It shows us how we can feel that we are being looked at by something that fails to see us. In the artist's act of tracking and assembling, this separation is made manifest, as she tries to restore to the eye the dimension of seeing, of the gaze that singles out its object. Fishmongers know all about this. They witness, on a daily basis, their customers' fascination with the dead eyes of what they sell. But what would happen if these dead eyes blinked, and then turned towards you?

Portraits, of course, cannot see us. But, even so, we sometimes can't quite help feeling that we are being watched. All portraits, Ernst Gombrich once argued, follow us with their eyes unless they clearly 'look elsewhere', and this feature has been famously exploited from the Gothic novel to the modern ghost story. The fact that a portrait can instil unease in this way is another example of how we often feel looked at by something that does not see us. We know rationally that we have nothing to fear but a painted canvas, yet none the less the lifeless, dead eyes have a disquieting effect.

In his account of the theft of the *Mona Lisa*, Peruggia claimed that at first he had set his sights on another painting, but on passing the *Mona Lisa* he had the strange sensation that she was smiling at him. Although he would give different versions of the events leading up to the theft, this reference to an interpellation should not be discounted. It suggests that at some level he felt he was being looked at. And

indeed, when figurative artworks are vandalized or defaced, the first target is usually the eyes, as if they have to be disarmed before the remainder of the assault can continue. But why this separation of seeing and looking? Why should an eye that doesn't see sometimes take on a more threatening quality than one that does?

The distinction between the eye that doesn't see and the eye that looks frames the two main Western theories about light. For many years, it was believed that, in order to see, the eyes emit beams of light. This is called the extramission theory of light and, as evidence, the shine of a cat's eyes at night was often evoked. Rather than allowing this theory to be refuted by the fact that the sun and stars obviously emit light but don't see, it was assumed, at least by Homer and Hesiod, that, on the contrary, the celestial bodies look at us. Displacing the extramission theory was the propagation or intromission theory of light, according to which light travels not from the eye to objects, but from objects to the eye.

Although versions of these two theories co-existed for several hundred years, the intromission theory became the dominant scientific paradigm. Its victory might seem obvious, given the apparent absurdity of the extramission idea, yet several recent studies have shown that extramission is still a widely held belief. Almost 40 per cent of American college students taking part in one experiment thought that the eyes emit beams of light. This anomaly, which surprised the experimenters, merits explanation, and we will see later how the extramission theory contains a core of truth that can also tell us something about visual art.

With the development of optics in the seventeenth century, visible objects were reduced to point sources of light. An object became a set of points, each one tracing a straight line

to the eye, so that an optical pyramid was formed with its base in the eye and its apex in the object. Light rays became identified with geometrical lines that existed independently of any viewer, unlike the visual rays posited by antiquity.

When the old *Superman* comics showed their hero's X-ray vision, they put the apex of the optical triangle in his eye and its base in the object. This 'mistake' might have been a subversive attempt to revive ancient theories of vision, in the same way that other products of pop culture spell out a black mass if you read them backwards. But if we assume a knowledge of modern optics, the inference is that although Superman thinks he is looking at objects, accessing the truth of reality thanks to his ability to see through walls, it is in fact the world that is looking at him. To escape from the unbearable state of being continually looked at, he has to change back into Clark Kent.

That this is an unbearable state is clear from the fact that most people can tolerate being looked at only when they are wearing a mask. If they are caught unawares, suddenly registering the gaze of an unannounced spectator, the feeling is often shame or anxiety, even if they aren't doing anything particularly private. We tend to feel more comfortable when we assume the required persona, depending on the social situation we find ourselves in. Ordinary social life, as many writers have observed, is about wearing these masks. Clark Kent's activities might be a bit dull, but at least he has the security of his mask: without it, he loses the dose of anonymity that human existence demands. As Superman, everyone, and everything, is always looking at him.

The modern optical model was initially supposed to show us how images form in the eye. Straight lines from each point on an object's surface would converge on the retina,

painting a picture there of the object we were looking at. But if the retina is a surface, how can we perceive three dimensions, and if each point on the object projects a point on to the retina through a straight line, how can we see distance? One answer involved geometry. We calculate the angles of the triangle formed by the point on the object and those in the eyes, and we do all this without knowing it. There is a diagram in Descartes's treatise on optics showing a blind man holding out two sticks to touch an object. The sticks materialize rays of light, and calculating the angle at which they converge on the object will allow him mentally to calculate the object's distance.

This much reproduced diagram served as a paradigm of the act of seeing. Visual space becomes a mathematical space that could be mapped out using sticks or, better, threads of material. The irony here is that if we equate the geometrical mappings of visual space with vision, then the blind can see. As light became mathematical, what place was there for the seeing subject?

Reducing light to geometry meant that the diffusion or radiation of light became privileged over the question of light as a substance or body, the light that can overpower us and that we have to defend ourselves against, the light that we buy SPF to block out. Indeed, many of the ground-breaking texts of medieval optics had argued that vision is in fact a form of low-level pain that tells us we are seeing. With the marginalization of such ideas, the *lumen* of the radiation of light rays eclipsed the *lux* of light as brightness, as fire, or as a source of meaning or of pain. Where many of the texts of antiquity had studied vision, much of the new optics was all about light. And light, as mathematical, had now become almost invisible.

With these new ideas about visual space came a new philosophy of mind. As the retina became the site of the convergence of light rays to paint a picture of the object inside the eye, so the mind, for some philosophers, became identified with a camera obscura, a darkened chamber in which images are formed through a small aperture opening up on to the world outside. We see not objects but pictures of objects, and these pictures are the result of the mathematics of light. It is through the geometry of triangles and cones that we can calculate the distance and orientation of objects, for example. Rather than the antique idea of the eye as the emitter of light, the geometry of vision suggested that we are fundamentally receivers of light: like a camera obscura, a human being is a picture-capturing device.

This idea seems so simple that it is easy to overlook its importance. What, after all, could be more natural than to suppose that we receive visual images from the outside world? Yet these assumptions about vision carry a lot of baggage with them. They implied, for some thinkers, that we do not see the visual world directly but only through the filter of two-dimensional images and, furthermore, that the mind is like an enclosure, a private space that contains images. Historians and philosophers have made much of these changes in the theory of light and vision. What interests us here is the question of how psychoanalysis engages with this problem of our relation to the visual image. Is a human being really a picture-capturing device?

Bridget Riley might not agree. Approaching her mono-chrome paintings has a notorious dizzying effect. As we try to look at them, we find that we are unable to take them in all at once. In a work such as *Late Morning*, the arrangement blocks any possibility of the 'œillade', the single glance

that takes in the whole picture. All we can do is circulate within it.

Although strictly speaking Op Art – the label given to this style of disorienting, geometric work – is no different from many other art forms, it shows how a picture can affect the viewing position of the spectator. We try to bring our eye to it, to capture the image, but the image fights back, pushing us and pulling us in different directions. It is this lack of symmetry between viewer and visual image that interested Lacan early in his career.

In 1932, the year that Lacan published his doctoral thesis, the US government funded a study of mimicry, the propensity of animals to take on the colourings of their habitat or the appearance of other species. Opening up the stomachs of some eighty thousand Nearctic birds, the principal researcher McAttee found that the insects that could disguise as landscape fared no better than those that couldn't. Mimicry failed to increase one's chances of survival in a cruel world. A zebra might feel safe in Bridget Riley's

garden, but its chances were actually no better than anyone else's. So if it didn't help you to look like a rock or a twig or Op Art, why bother?

Today, evolutionary explanations of mimicry are dominant, but in the 1930s there was some excitement about what seemed to be an anomaly. One of the more fanciful theories appealed to a general law of imitation: we become like our habitat, and this becoming is a law of nature. Humans and animals are similar according to this view. We might not share the markings of our visual environment in as striking a way as the subject of Richard Billingham's photograph, but we none the less blend in, we identify.

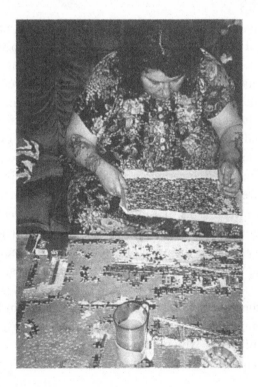

Lacan had a different idea. Initially, he saw a continuity between the way in which an animal might be captivated by an image and the way in which a human infant is captivated by mirror surfaces. Yet, unlike most animals, infants, he argued, are born prematurely. They can't walk or defend themselves or find food on their own, and their nervous systems are far from complete at birth. Faced with this state of bodily uncoordination, the child will identify with visual images that offer the promise of wholeness and completeness. This may take the form of a mirror image, the image of another child or that of someone else in the child's environment. These are the images, he thought, we will be sucked into.

Identifying with a visual image will allow the progressive mastery of motor functions: the child will learn to walk, to grasp objects, and to use its body. Indeed, more recent studies have shown how infants mimic those around them right from the start of life. Their facial expressions imitate those of the care-giver within the first few hours after birth. And, as adults, we have increased lip activity and eye-blink when observing models who stutter or blink excessively. There seems to be something automatic about such processes, as if we are captured by surface cues long before we develop cognitive mechanisms that might make sense of them.

But being pulled into an image is alienating. It gives us our bodily unity at the price of a split, a discordancy in our identities. We are not identical with mirror images, and we can never fully go into their place, just as we can never fully go into the place of other people. This might seem to be a trivial point, but it is one of the fundamental aspects of human suffering. We could evoke here the many different problems people experience in relating to the body image, as

well as the dissatisfaction that haunts those set on acquiring the material objects possessed by others. One consequence of identifying with someone else, after all, is that what we want is defined by what they want.

Lacan's point here is not simply about a developmental process, but about the power of images to capture us. Images mould us, transfix us, captivate us and alienate us. As adults, we may sometimes become conscious of this when we find ourselves imitating the gestures or tone of voice of someone we know. We might not intend to copy them, but we suddenly find ourselves doing it.

When Elaine Fried's boyfriend lost her to Willem de Kooning, their friends were bemused to notice the spurned lover start speaking with a Dutch accent. Rather than seeing such identifications as isolated phenomena, both Freud and Lacan saw them as essential to our identities. We become who we are partly through becoming like others. Far from being picture-capturing devices, humans are perpetually being caught by pictures. An image, or picture, is a human-capturing device.

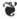

Is there a difference here between a work of art and any other kind of image? Surely the same argument can't apply across the board, since otherwise we would all become like the pictures we see. We don't have to leave a baby alone for its formative years in the company of a Van Gogh to know that this can't be the case. Some visual images will matter and others won't. And as we explore this question, we will see how it can tell us something about those images that are sanctioned as art. The first point to be made here is a very

simple one: that there is a difference between a visual image and the *place* that this image occupies.

Images capture us, as Lacan argued, at the point where our biological development is experienced as inadequate, to set up a pattern of alienation in images. These images will be bodily, visual images, and some will matter and not others, depending on the circumstances of our early years and the interests of our care-givers. If, for example, one of our parents shows a special tenderness towards a sibling, the image of that sibling might become our own. We might, at some level, strive to become like them.

Identification is not only about images, since an image has to take on a value for us first. If an infant is captivated by its image in a mirror, it will often turn to a parent to receive an acknowledgement, some gesture that would sanction the image as *its own*. This could be a nod or a smile or some words. Visual images on their own might trap us, but for our capture to become more than transitory, they need to take on a symbolic, signifying value. A place has to be made for them. Crucially, they need to mean something for *someone else*. And values tend to be set for us by how we perceive the interests of our care-givers. People's political affiliations, for example, are almost always either a direct echo of those of a parent or their exact opposite.

Our own body image is linked to the question of what we think a parent sees or wants to see, and indeed, for our image to become our own, it has to be recognized as such, sanctioned for us by the other. Although this might be difficult to comprehend at a conscious level, it becomes clear at moments when the way the other looks at us is put in question. The painter L. S. Lowry, for example, was caught up in a powerful relation of dependence with his demanding

mother, and throughout his life would say that everything he did had a meaning only for her. During her fatal illness, he found himself looking into his shaving mirror, seeing a strange face staring back at him. This alienation from his own body image was experienced by Lowry as he painted a series of staring, male heads during the same period. He would say that these heads 'just happened'. Rather than being crafted with design, they just appeared on the canvas, and many years later he could still ask a visitor to his studio, 'Why do I do them? What do they mean?' In the words of one of Lowry's friends, these portraits took form 'as if he had nothing to do with their creation'.

The key here is in the feeling of strangeness experienced by the painter. The works just happened, as if they didn't belong to him, exactly as the image he saw in the mirror took on this same quality of depersonalization. What connected him to the image, what made the image *his own*, was linked to Lowry's relation with his mother, and as her sanctioning or condemning look threatened to disappear, so his own links to his body image evaporated. The place that his image occupied had changed, and so the image lost its anchoring point.

A similar thing happened to Nick Leeson, the man who brought down Baring's Bank. As the image of wonder boy that he tried so desperately to maintain began to dissolve, he would avoid eye contact with his own image in the mirror. What these examples show is how our own visual perception of ourselves depends in part on how we think we are seen by someone else. When there is a change in this look, our own image is put in question. We could evoke here the well-known experience of disappointment in love: when a lover is confronted with the loss of their beloved's affections,

isn't one of the first things to happen a change in their relation to their own image? This might take the form of a hatred of this image, or the desire for change, seen, for example, in the adoption of a new fashion style or haircut.

But what about the relation of the captivating image to the work of art? Curiously, it is the fascination with the mirror image that led to the discovery that the world's most famous work of art was missing. When the Louvre put the *Mona Lisa*, and other works, under glass for the first time, there was much outcry and indignation. How could the museum dare to taint our appreciation of a masterpiece with the spectre of our own reflection in the glass? One protestor went and had a shave using the glass covering a Rembrandt self-portrait as his mirror. Great paintings had become simply the tools of our narcissism. Indeed, the legendary art dealer Duveen had already been in the habit for some time of heavily varnishing his paintings, having noticed that his clients enjoyed seeing their own image in the works presented to them.

With this idea in mind, the painter Louis Béroud decided to make a study of an elegant model arranging her hair in the mirror that the *Mona Lisa* had now become, thanks to its protective glass. Arriving at the museum on the morning of 22 August 1911, Béroud and his assistant headed for the Salon Carré, and there, in between Correggio's *Mystical Marriage of St Catherine* and Titian's *Allegory of Alfonso d'Avalos*, they found four splendid iron pegs, but no *Mona Lisa*. When the guard arrived, he thought it must have been taken down to the photography annexe, an attitude that *The Times* described as displaying 'a lack of organized responsibility'. No one was particularly fazed, and Béroud hung around for a few hours before calling the guard again. This

time, he checked with photography, and learned that they hadn't got it. When further searches proved fruitless, they called the police and the *Mona Lisa* became officially stolen. The pane of glass that had drawn Béroud to the scene in the first place was found in a spiral stairway leading into a courtyard, but now, alas, it was of no use to anyone.

The Louvre guards soon discovered that the painting had in fact been stolen the day before, but no one had noticed its absence until Béroud came looking for a reflection. As a chapter in the history of putting works under glass, the theft of Leonardo's painting therefore had a simple message. If our access to the world of art was contaminated through the imposition of the reflected body image, we might as well keep our vanity and do without the artwork. In this sense, the *Mona Lisa*'s absence was logical. And it showed the splitting, rather than the superimposition, of one's mirror image and an artwork.

And yet, with hindsight, the Louvre's base gesture of putting Leonardo's masterpiece under glass would only confirm the worst suspicions of some of its later students. Faced with the dreadful problem of working out whom the picture is supposed to represent, and with only inconsistencies and contradictions in the historical data, it has been argued more than once that the bemused sitter was none other than Leonardo himself. The painting is literally a mirror. There are examples from the period of men being painted in female garb, and the hypothesis that this was indeed the hidden truth of the *Mona Lisa* seemed confirmed, to its enthusiasts, when a computer graphics expert claimed in 1987 to have scientifically found the outlines of Leonardo in the female figure.

In his study of Freud and Leonardo, Bradley Collins

points out that this narcissistic reflecting is explicitly contra-indicated by the artist himself. Speaking of the 'greatest fault in painting', Leonardo criticizes those who 'in all their figures seem to have portrayed themselves from the life, and in them one may recognize the attitudes and manners of their maker . . .' We find this also, he continues, in the many men who fall in love with women who resemble them. This theory of narcissism in a nutshell is understood by Leonardo as a danger to be guarded against, rather than as a model to be prescribed. Which isn't to say that he didn't do it, and perhaps Duchamp's famous *Mona Lisa* with a moustache and goatee was the modern artist's way of adding his own consensus to the man in drag theory.

Ironically, the emphasis on mirror reflection that had led indirectly to the discovery of the *Mona Lisa*'s absence and, for some, revealed the truth of the portrait, was to become only more entrenched after the theft became official. What, after all, did the Louvre choose to put in its place? Not a portrait of a woman, but, in a gesture that must have added insult to injury, that of a man: the *Castiglione* of Raphael, whose pose loosely resembles that of the *Mona Lisa*. When S. J. Freedberg described this painting many years later in his influential monograph on painting of the High Renaissance as 'a transcription – into male gender – of Leonardo's model', he did it in all innocence of the Louvre's cheeky dis-placement.

The splitting of mirror image and artwork can illuminate a difference between the way that humans and animals relate to captivating images. Although both may be captured in

certain images, Lacan thought, humans could use the image in quite particular ways: 'The human subject', he says, 'is not, unlike the animal, entirely caught up in this imaginary capture. He maps himself in it. How? In so far as he isolates the function of the screen and plays with it. Man, in effect, knows how to play with the mask as that beyond which is the gaze.'

This difficult passage introduces some new terms: the screen, the mask and the gaze. If humans and animals are captivated by images, it is humans who can use the image as a sort of defence. It can become a shield or, more precisely, a lure or bait to distract the gaze. The gaze here means the look of someone or something else, a look that makes one anxious and terrified. Some animals can certainly use the visual image to petrify predators or to attract mates, but there is something singular about the way that this practice is woven into human experience and culture. We saw earlier on how at the dawn of our visual awareness we can feel looked at, a state against which we have no protection, and which for that very reason may be felt as menacing. This is the look that folklore has imagined as the evil eye, and Lacan thought that there was always a dimension of evil rather than benevolence in the look. This is the dimension that we sometimes find revealed in psychosis, where there is the conviction of being watched or spied on. Although this malevolent function of the look is clear in such extreme examples, Lacan believed that it is present for all of us at a latent level. Our everyday reality is built up around its exclusion, and when it emerges, the fabric of our reality breaks down.

This can happen on the way to work. Many travellers pass their time covertly surveying their fellow passengers,

often extending their surveillance into sexual fantasy. They might daydream of an exchange of dialogue, of phone numbers, a burgeoning romance or sexual passion. When the object of their reverie gets off the train, they might feel a momentary sadness, the sense of lost opportunity. But this sadness is nothing compared to the feeling of anxiety if the other person not only looks back, but fixes your gaze. If the visual field is a privileged route for our libido to attach itself to objects, nothing prepares us for when the object looks back.

And in fact, when we desire in the visual field, we expect that the object of our desires remains just that, an object. The problems start when what is supposed to be a passive object shows that it is also desiring. Reality can be nice or dreary, as long as we keep this desiring dimension of the other at bay. Someone else's desire makes us anxious to the extent that we don't know what it is that they want. It is usually easier for people to assume that they do know, for example, what their partner wants, even if this is only the product of their own projections. When they are confronted with the enigmatic dimension of their partner's desire, they might suddenly feel that they are in the presence of a complete stranger. And this, in turn, makes their own place precarious and unstable.

If we assume that it is we who look at the world rather than the world that looks at us, our own position might seem more secure. But, as our examples showed, such security can collapse, and works of art often draw on this principle of visual reversal. In Susan Morris's video piece *Parallel Universe*, we see the serial windows and doors of an apartment block and wait for something to happen. As in Hitchcock's *Rear Window*, we scrutinize the different visual frames they have to offer as the camera remains immobile. Nothing

changes, and as we search fruitlessly for any sign of life or movement, we become uneasy. As we strain and stare for something to feed the eye, we realize that rather than us looking at the building, the building is looking at us.

The malevolent look is embodied by the opaque windows, beyond which we see nothing. The work shows us once again how we can feel looked at by what doesn't see us. Discussing Hitchcock's *Psycho*, Slavoj Žižek observes that when Marion is approaching the old dark house on the hill, we see it exclusively from her point of view: there is no neutral, 'objective' shot of the house, just as there is no shot from behind its curtains, as we find in so many other horror films and thrillers. Such a shot, accompanied by heavy breathing, to indicate that someone in the house was watching her, might add to the tension, Žižek says, but it would also render the menace that awaits her more subjective, more identifiable.

What makes the sequence so troubling is that although the house is looking at her, she cannot see it at the point from which it gazes back at her. She cannot know what she 'is' for the house. The paradox of the look here is the fact that it often takes on the form less of real human eyes than of surfaces that we cannot gauge or see through. They embody the menacing, enigmatic dimension of the look. Just as our entry into the social world entails an exclusion of this dimension of the look, so its emergence will be distanced from the human eyes that surround us: eyes that don't see or opaque surfaces thus take on the threatening power of the look, and their lack of any 'subjectivity' endows them with desire. Not everyday desire for empirical objects, but the strange, enigmatic desire of the Other that we are confronted with from the dawn of life, the desire that makes us ask: What are we for the Other? What does the Other want from us?

We can recall here Freud's argument that our visual reality is constituted by an exclusion. In this case, it is the exclusion of the malevolent look, the point from which the other sees us. Since it is excluded from our everyday reality, we sense it primarily when we encounter not simply eyes as such but the form of eyes, something opaque and menacing. Like the CCTV cameras of Anita Witek or the house on the hill in *Psycho*.

In the animal kingdom, there is a difference between the ocellus and the eye. Eyes can see but the ocellus has a different function. It consists of a simple as opposed to a compound eye, but may also take the form of an eye-shaped patch on the animal's body surface, usually much larger than the eye itself, surrounded by a ring of colour. When the animal is in danger, it can reveal its ocelli in a terrifying way to the predator. The predator is fixed by the sudden emergence of eyes that do not see, and Lacan linked this to the uncanny aspect of the eyes of the blind. They look at us but, strictly speaking, the ocelli don't see us. They show themselves, breaking the background of invisibility that the animal's camouflage may have maintained.

When children play their many games of hide-and-seek and concealment, we find the same juxtaposition of invisibility and exposure. To remain undiscovered is a central preoccupation, but this camouflaging is there only to prepare for a sudden, and often frightening, appearance. Perhaps one of the functions of such games is to tame the malevolent side of the look, to socialize it. The unpredictability of a terrifying dimension is given, through the games, a certain rhythm or organization. There may be a pleasure in this, yet it is significant how so many people have memories of when such games went wrong: how they remained hidden for too

34

long, or their fright at finally discovering another child or being discovered themselves.

A photographic lens can function in the same way as an ocellus. It doesn't see, and yet, like the ocellus, it has the form of the eye, which means that a lens can have a more unsettling effect than an eye that sees. There are many stories from the early days of photography about the terror instilled by the camera, as if it were stealing some aspect of the model's subjectivity, or even their life. Today, as the camera has become so much more familiar, we might not worry if someone takes our photograph once or twice. But if someone persists in taking our photograph not once or twice but hundreds of times, we might assume, justifiably, that they want to kill us.

Although we encounter eyes all the time, when we start to notice them, to become unsettled by them, that's when they start to embody the presence of a desire, something that we can't predict or negotiate. In the film *Aliens*, there's a scene in which the space troopers enter a cavernous section of a planetary base and their instruments start to register the proximity of life-forms. But they see nothing. Until the walls literally come alive, and the aliens, which had remained invisible, launch their attack. Their camouflage made them a part of the picture, unnoticed, and their attack has all its effect precisely because of their prior invisibility. Breaking invisibility is identical here with a horrific desire, and it illustrates the split between the eye (the invisible dimension) and the look or evil eye (which embodies a monstrous or threatening desire).

We can find this split in the work of a painter famous for not really horrifying anyone, apart from the critic Brian Sewell, who considered popular England's love of Lowry as

almost a state crime. Lowry's industrial scenes and portraits seem tame and pleasing: they emphasize the bustle and movement rather than the drudgery and pain of the factory lives they document. A bachelor all his life, Lowry apparently avoided both romance and sex, yet he entertained a succession of teenage girls, whom he would turn into trusted companions. When the thirteen-year-old Carol Ann Lowry wrote to him in 1957, he paid his unrelated namesake a visit and a long friendship developed between them. The painter encouraged and supported Carol Ann's interests and studies, and he behaved with great correctness throughout the many years they knew each other. He was 'uncle' to her, and she was 'niece'.

After Lowry's death, as the main beneficiary of his estate, Carol Ann received a phone call from the executors inviting her to the NatWest bank in Manchester to examine some things that had been found in the painter's home. The Lowry works that greeted her could not have been easy to look at. They consisted of drawings and paintings of a young, slim girl, dressed up in a variety of costumes. But rather than depicting her in the everyday situations that were so dear to Lowry the public artist, this subject was being decapitated with an axe, pushed under a guillotine, strangled and cut open with a knife. As she looked through this grizzly series of pictures, Carol Ann could feel herself going cold and the hairs start to bristle on the back of her neck. Recognizing the distinctly *retroussé* nose of the subject as her own, she realized, 'My God, it's me. They are me.'

Although she would later come to consider the girl in these pictures as an imaginary figure for Lowry, the initial moment of horror indexes something that touched her powerfully. If the painter had always behaved perfectly with her,

the macabre series showed that the vision of the world broadcast by his public art and by his conversation hid another way of looking at things. The images showed a look saturated with sexuality and unspeakable violence: it is not the graphic content of these scenes that is so disturbing, but the fact that they point to the place from which they have been painted, Lowry's horrific and obscene look. Beyond the way she thought she was looked at by him, there was another look. She had been looked at by him in a way she could never have imagined.

This shock would find an echo many years later when Carol Ann was contacted by the art historian Michael Howard. He had noticed that hidden in some of the well-known scenes of bustle and street life was a tortured female body, visible if the picture was looked at sideways. Odd-looking buildings, for example, disguised the outlines of the body of a girl in agony. Confirming Howard's discovery with works from her own collection, she would say, 'It was not the subject of the hidden drawings that bothered me, not their erotic nature. It was the fact that they contain something hidden. The fact that the girl is hidden.' The invisibility of the industrial scenes and innocuous portraits is thus broken when the presence of another look is introduced. Although we might have been looking at these pictures in one way, the painter was looking at them in another.

The true horror here lies in the fact that this implies logically that our own act of failing to see is being looked at by the painter. He is looking at what we, the viewers, are failing to see. In Lowry's perverse universe, it is less we who are looking at the painting than the painting that is looking at us. His eye is built into the picture.

Doesn't this idea of an evil eye looking at us provide a

clue to the strange persistence of the extramission theory of light, the belief that light is emitted by the eye? The survival of this theory despite all the obvious counter-examples suggests that it contains a truth: the eye, in its evil dimension, reaches out and extends, grasps and menaces, like the projecting cylinders that Picasso created when he pulled out rather than pushed in the clay that was to embody the eyes of his figures. And since this dimension of the look is generally masked, when it emerges it seems to distort space and smudge the visual reality we take for granted.

It has often been pointed out that Buddhism is different from other systems in its avoidance of the imagery of terror, and the attitude to Buddha statues involves respect and affection. But latent to this pacifying screen is an odd detail, the fear present in the consecration of such statues before they can become objects of worship. The act of consecration is simple enough: it consists of painting in the eyes or carving the pupils of the Buddha. Although modern manufactured Buddhas dispense with this symbolic act, the traditional ceremony makes of it a necessity. In a fascinating article, Richard Gombrich discusses the terror involved in this dangerous procedure, which carries the risk of arousing the malevolent tendencies of the supernatural being.

While painting the Buddha's eyes, the artist cannot look the statue in the face, but works with his back to it, painting sideways or over his shoulder using a mirror, which catches the gaze of the image he is bringing to life. Once he has finished his work, he now has a dangerous gaze himself, and is led away blindfolded. The blindfold is removed only after his eyes can fall on something that he then symbolically destroys. As Gombrich drily points out, 'The spirit of this ceremony cannot be reconciled with Buddhist doctrine, so

no one tries to do so.' But isn't the key precisely this bizarre heterogeneity? The fact that for the temperate and pacifying reality of the Buddhist universe to function, the horrifying, malevolent gaze has to be symbolically excluded. The evil eye has to be tamed.

Which brings us back to the question of the image, the screen and the gaze in relation to artistic creation. Lacan's idea is that, in some cases, visual art functions as a screen to divert the evil eye, to disarm it. In the same way that a threatened animal will divest itself of a part of its own body to mollify its pursuer, the artist can divest him- or herself of an image. Just as some birds may 'terror moult', shedding feathers when confronted with a predator, humans have a habit of dropping things when threatened. We could think of the many folk tales in which someone is being chased and drops a magical object behind them to block the pursuer. The artist, in a similar way, drops images or objects in order to survive.

Psychoanalysts often embarrassed themselves in the past by comparing the creative work of artists with infants' experiments with their own excrement. Just as the unsupervised child plays around with its shit, so the sculptor, for example, plays around with their clay. Imagine the delight shrinks must have experienced when Jackson Pollock broadcast the reminiscence of having watched his father peeing on a flat rock, making patterns with the jet of his urine. Unfortunately, the art-out-of-excrement theory proved rather limiting, closing doors rather than opening them. But the reductiveness of such views can be inflected with the idea of the terror moult. Although today we tend to interpret shitting at moments of anxiety as a physical sign of panic, there was a common nineteenth-century belief that

shitting in fact was a form of protection. Burglars, for example, would leave their excremental trace not because they were worried but because they thought it would safeguard them from detection. Like the birds and the characters from folklore, they dropped something to save themselves.

We could evoke here a neglected aspect of one of the most famous anecdotes found at the start of art-history books, the story of Zeuxis and Parrhasios. Zeuxis paints some grapes that are so lifelike that they attract birds. Parrhasios then invites him to pull back the curtain covering his own master-work, but when Zeuxis tries to do so, he finds that the curtain itself is the painting. The story is usually read as a comment on the nature of representation, although, together with so many other vignettes about Greek art, it is also telling us that at the heart of classical art is a problem of competition between men. But what interests us here is the dimension of deception.

The birds are apparently fooled by Zeuxis' grapes and Zeuxis is fooled by Parrhasios' veil. Some classical commentators wondered why the birds weren't scared off by the boy that Zeuxis painted with the grapes, but this is to miss the point of the story. Zeuxis is in a symmetrical relation with the birds, deceived by an image. The birds, in fact, are just like us: they peck at something they cannot eat, in the same way that humans are captivated by images that fail to deliver the plentitude they promise. There is a heterogeneity between our desires and the objects we think will satisfy them, which is why cereal packets often contain cheap plastic toys. We can eat everything, but real food is never enough to satisfy the oral drive: the toy incarnates this dimension of the remainder, the fact that there is always something beyond what we think will satisfy us.

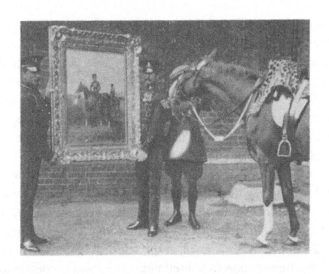

Although the story of Zeuxis and Parrhasios may be understood in terms of a local conflict between artists, it is telling us that the artistic image is there to *capture a look*. Intrinsic to the image is the effort to lure the look, to deceive it, rather than simply to mimic reality. Indeed, ancient optics was preoccupied with the question of how the eye can be fooled, rather than that of the internal geometry of the eye or the nature of light. Likewise, Plato's discussions of visual art are often interpreted in terms of the relations of reality, ideas and representation, but much of the art he was talking about had this specific function of trying to fool the viewer. Not to represent well, but to fool. The tension is not between the image and reality but between the look of the other and the painter. What he paints is there to attract the other, but to attract the other *away from him*.

Isn't this the true sense of the title Malraux's translator gave to his book about Picasso, *Picasso's Mask*? Much has always been made of this painter's encounter with African

art, particularly the tribal masks that were to captivate him at the Musée Trocadéro in Paris. Picasso told Malraux that he had immediately understood why these artefacts had been created: 'I too believe that everything is unknown, everything is an enemy! Everything! . . . All the fetishes were used for the same thing. They were weapons. To help people avoid coming under the influence of spirits, to help them to become independent. They're tools.' And, he added, 'At that moment, I understood why I was a painter. All alone in that awful museum with masks . . . The *Demoiselles d'Avignon* must have come to me that very day, but not at all because of the forms: because it was my first exorcism painting.' Malraux, it has been argued, respected the painter's wish to keep this information to himself until after Picasso's death: to have revealed it would have dissolved the protective powers of his figures and he would have become prey to whatever it was they protected him from.

The mask and, for Picasso, the painted figure, were there to ward off a malevolent Other, and it is no doubt significant that one of the very few things ever recorded of his mother is the comment that as a child her son was 'an angel and a devil in beauty, and no one could cease looking at him'. This evocation of the invasive presence of the look suggests that Picasso's masks were there to protect him from just that, to produce the Lacanian optical pyramid of subject, mask and look of the other. And doesn't this explain the problem that has perplexed both art historians and analysts, the strange recurrence in his work of stock figures such as the harlequin, the bullfighter or the musketeer? Although these figures may be linked to particular biographical episodes, don't they matter less for what they represent than for the simple fact of being uniforms: we can wonder why he chose this or that

costume, but the key is that they *are costumes*, that is, forms of the mask. The mask is there not to *express* anything, but to ward off an evil force.

The word 'mask', indeed, derives from the Greek word for 'amulet', an object with a protective function to lure and absorb the influence of the evil eye. As Francis Bacon said to David Sylvester, painting is about setting a trap. In our sense, a trap for the eye. This can take many different forms. Think, for example, of the way that Rubens and Delacroix repeat hues and light values to lead the eye from one part of a picture to another, following a rhythm. We might have set our own agenda, but the picture works against this, moving our eye like the internal rhythms of Op Art. As Gainsborough put it, painting is there to provide 'a little business for the eye': it is kept busy, and, crucially perhaps, away from the artist.

This effect can be produced through the serial production of single works, as with Picasso, or through the complex architecture of an isolated work: a construction such as the cathedral at Amiens, for example, functions as an immense trap for the eye. A similar effect can be found in a place frequented almost exclusively by artists themselves: the traditional art supplies shop. The extraordinary contraction of so many little bottles of paint, varnish and other ingredients to the usually tiny retail space produces an effect similar to a first encounter with Gothic architecture. Wherever we look, there is something to attract our gaze.

Art in this sense is desperate. As Degas said, painting 'requires as much cunning as the commission of a crime'. It is less the relaxed pastime of the aesthete than a furious defensive manoeuvre to ward off a malevolent Other. The pleasing, satisfying quality of some art diverts our attention

away from this darker thread. No wonder that Picasso's friend Sabartès was nonplussed when the artist replied to his query as to why he worked with the remark, 'so as not to throw myself out of a window'. Or Louise Bourgeois, that 'if I could teach a course, it would be a course in survival'.

A comparison might be made here with the practice of doodling. Some people are incapable of being in the presence of a blank piece of paper without inscribing something on it. And sometimes the moments of doodling occur at quite precise times: when we are listening to someone rabbiting away on the phone and it would be impolite to terminate the conversation. Innocent as it may seem, the doodling is a sort of response to the invasiveness of the other's speech, a way of transcribing not their words but their intrusiveness. Artists often have the feeling that they have to create something at a particular moment, just as writers may have the enormously powerful urge to write something, even if they haven't got a clue what it is they are going to write. Such transitory phenomena of passionately wanting to make an inscription are indeed quite common in most people's adolescence.

The pressure in these cases is to make some sort of mark, suggesting that at those times when we have an experience of being overwhelmed, it is not simply a question of making sense of it, of giving it a meaning, but just of making an inscription. Obviously, human beings respond to painful circumstances by trying to make narratives out of them, but this notion of inscription is much more archaic. It is less about making stories than about making marks. Something can be fixed or arrested by making a mark, as we see, for example, in the feeling of relief sometimes experienced by 'self-harmers' after they have made a cut in their body surface. And it is a positive step in such cases if, perhaps due to

a therapy, it becomes possible to make marks on paper or canvas rather than on the flesh itself.

As Paul Klee drew constantly, covering any available surface from menus to newspaper borders with configurations of lines, it is difficult not to suppose that this was his way of dealing with an internal feeling of being invaded, overwhelmed. This was an artist, after all, who complained that he felt looked at from all sides: even on his trips to the country, he said, 'it was not I who looked at the forest', since 'the trees were looking at me'. This feeling of being 'submerged', he added, was perhaps the reason why he had to paint.

It is quite possible that the sustained creative practices of many artists can be understood in the same way. We could think, for example, of the almost automatic character that artists often ascribe to their ways of working. There is a kind of circuit here that goes from the invasiveness of the Other to the use of one's own body to make inscriptions. One might wish to see this as a form of discharge: a better term might be barrier or limit. And isn't the crucial moment in the act of inscription, after all, the moment when one *ends* a line or mark or brushstroke? This is less an art of representing than an art of stopping.

The key to getting the psychoanalytic point here is to realize that the invasiveness we have made so much of is unconscious. Artists don't sit there thinking of how they can make things to divert an evil eye, but their production can be situated in a field that includes as a crucial reference point a voracious and unsatisfiable presence. This is not their dealer, but something more archaic, invisible, enigmatic. What is it?

45

After Vincenzo Peruggia walked calmly into the Louvre, he removed the *Mona Lisa* deftly from the four iron pegs that held her to the wall, dumped the heavy frame in a stairwell, and with the panel hidden beneath his smock he exited the museum and took the bus home. The painting had a new address, and there it would remain for the next two and a half years, although possibly enjoying a brief spell hidden with neighbours. Whatever the facts of its location, it seems sure that there was no peeking. Peruggia insisted that he had kept the *Mona Lisa* away from human eyes, not daring to gaze at her wondrous face himself, yet harbouring her like *'une chose sacrée'*.

When Peruggia did socialize, rather than showing off this prize possession to his intimates, he chose to play the mandolin instead. The police and journalists who descended on the Italian community that Peruggia inhabited searching for details of his daily life found that although no one knew anything about the *Mona Lisa*, they all knew about his musical evenings with the Lancelotti brothers. Sequestered from view, deprived of human contact, party only to the muffled sound of the mandolin, a philosopher might raise the question of the *Mona Lisa*'s status during these captive years. If she was so unseen and solitary, did she continue to be a painting? If we reply with an immediate yes, our knee-jerk affirmation suggests something far from obvious: that a work of visual art does not have to be visible.

This question of visibility can give us a clue as to the nature of the invisible presence we evoked earlier on. The critic Harold Rosenberg observed in the early 1970s that art had become in many circles not something to look at, but part of the environment: 'It was not necessary to scrutinize it; one needed only to know it was there.' When he asked

Andy Warhol's dealer about an exhibition of silk-screened flowers about to open at his gallery, he apparently received the reply: 'No need to see it, the pictures are the same as the announcement I sent you.' The work of art mattered just for being there: one didn't even need to look at it. If we ignore the little dig at Warhol's dealer, we can ask what the anecdote is telling us about visibility as such.

We take it for granted today that visual art is designed to be looked at. Although lighting techniques may vary, it makes no sense to think of visual art that isn't seen. Before the backlash against some currents in modern art that might be evoked for us, for example, by Rosenberg's story, the question seemed to be raised only when someone asked from time to time if a Tintoretto that was used for years as a junk covering without being recognized was still 'a Tintoretto' during that period. Ditto for the hidden *Mona Lisa*. Such an enquiry is not uninteresting, but it presupposes that a visual work's primary function is still to be visual. Although hidden from view, it is there, ultimately, to be seen. But is the answer so clear-cut?

Take, for example, the religious painting that we can see only if we put a coin in the meter in a darkened church. Or the dazzling cave paintings that become visible only with a torch or artificial lighting. Or the designs and scripts of Islamic architecture that cannot be deciphered from the standpoint of the human observer. These are all cases of art that is visual, but that doesn't seem crafted to suit our own eyes. One might argue here that the explanation of this apparent obscurity lies in ritual and revelation. The images are kept in the dark only to give a special import to the moment when they are suddenly lit and revealed, to generate a sense of wonder and awe in the viewer. And it is difficult to find a

religion that doesn't involve such moments of revelation in its rites of worship.

Indeed, art historians have shown how the vocabulary used to prescribe how viewers should respond to art tends to derive from the lexicon of religious worship. With the changing status accorded to religious images since the Reformation, artworks may have left the churches, but the church's language slipped away with them. Even the idea of exclusive, absorbed attention to a work of art comes from theology. Augustine had elaborated the distinction between loving something for its use value, for an end beyond itself, and loving something for its own sake. Objects in our everyday reality are loved for their use value, but only to ascend gradually to the ultimate beauty and goodness in God, who is loved in a pure enjoyment for His own sake. Augustine's blend of Platonic philosophy and Christian theology was developed by other religious thinkers and ended up as a dominant model in art theory since the eighteenth century. Whereas the arts had previously been construed as diverse modes of making, the new aesthetics privileged the idea of individual works to be attended to by a viewer 'for their own sake': the notion of disinterested contemplation had its roots in religion.

Yet, curiously, where Augustine had assumed that the purity of this kind of disinterested attention was not to be attained before entering the Kingdom of God, the art theorists of the eighteenth century made it available within the span of a human life. Where Augustine had put 'seeing' at a point *beyond* ordinary human vision, the art theorists had brought it back *into* the field of human vision. And this is exactly where the problem lies with respect to the visibility of works of art: why assume that they are always meant to be seen by us?

The appeal to ritual and revelation is helpful in many cases, but it is not exhaustive. One might add to our examples the work that many artists refuse to sell and keep in storage. Should we assume that the image attains its value only at the moment of revelation, or does it have a function precisely at the moments when it is not being looked at? The designs and scripts of Islamic architecture do not seem to have a place in the ritual of revelation, yet they are clearly visible. Not visible to us at ground level, but to a point of observation situated in the sky: in other words, these works of art are designed to be seen less by human eye than by the deity. There is a triangle here made up of the human viewer who cannot see clearly, the work of art and the eye of the deity.

This dimension of a non-human eye might help us to understand the art of darkened spaces. Although it may matter to the human eye when it is revealed at certain moments in religious ritual, it is there fundamentally not to be seen by us but by something else. And to be seen by this something else does not necessarily require the light that the human eye demands. That's why illumination is not always the priority. The device of focused lighting on an artwork in the museum space is a relatively recent one, and one gets a sense of this 'being there' of an artwork in representations from the pre-museum and early museum era. Hundreds of paintings may compete for wall space in a poorly illuminated room, as we can see today, for example, at the museum at Chantilly near Paris.

The usual interpretation of this phenomenon is in terms of property. Artworks functioned as objects, less to be seen than to be amassed and hoarded, an aristocracy's privileged trophies that would later be displayed to a deprived public. With the French Revolution of 1789, their status would change from symbol of luxury to that of communal property,

testimony to nationhood and freedom. But even in the great Napoleonic Louvre, which would become a model for many other Continental museums, the isolation of artworks from their previous context was not so sharp. As one visitor observed, 'The effect upon a stranger's mind when he first enters this magnificent museum is better conceived than described. The eye is lost in this vast and original perspective; the sense is bewildered amid the vast combinations of art.' And another would comment, 'All is confusion and astonishment; the eye is dazzled and bewildered, wandering from side to side – from picture to picture.' If the avowed intention of the museum's design was to banish the habitat of the aristocrat in which precious objects of all sorts formed an obscene plentitude, the Louvre's arrangement was still overwhelming: although one could see the paintings, looking at them was made problematic by their massive and multiplied presence.

These art objects may have become symbols of a republic, but there was still something about them that made them objects to 'be there' rather than simply to be looked at. There is still the trace of the triangle of viewer, work and non-human eye. The work may no longer count as an object for its aristocratic collector, but it is there as an object for the unseen presence it is designed to appease. When Matisse said that art should have 'a soothing, calming influence on the mind', it is not simply a question of the mind of the viewer but of this Other that the artist – or even curator – does their best to mollify.

One might remember here that although we tend to think of artworks as objects to which we bring our eye, the history of images shows that in fact it was often a question of art keeping an eye on us: think, for example, of the medieval figures whose large eyes watch us from above, designed, arguably, to produce a sense of guilt or discomfort in the

viewer. When such figures left the churches, did they really stop looking at us? The use of this motif from the Gothic novels to Gogol's story *The Portrait* about the terrifying, malevolent eyes of a painting show that this was hardly the case.

Our argument here is quite traditional. It suggests that art never stopped being religious. Religious in the precise sense, however, of being designed partly as an offering. Art and religion converge here through the motif of sacrifice. What does a sacrifice involve? It is about the *making special* of some object and the offering up of this object to a deity. Art is also about a making special, from its more classical forms to the modern notion of the readymade, the everyday object that is now appreciated in a new light. As Walter Burkert put it, 'Art means to "make special" certain objects of perception, producing a characteristic tension between the familiar and the admirable and thus creating new aspects of a potentially common world.' This argument is neither troubling nor particularly new, until we add the most obvious yet overlooked inferences: if art and religion share the theme of sacrifice, what would happen if the sacrifice wasn't made? And if both involve an offering, what is this offering designed to ward off?

Sacrifices in religion can be divided into two groups: those that aim at getting closer to the deity, and those that aim at getting as far away from the deity as possible. It is this latter sense of sacrifice that we are talking about. The deity here is not benevolent but malign. It incarnates the demand for the pound of flesh rather than the offer of support or encouragement. And it may be linked to the aspects of our parents and ancestors that we experience, unconsciously, as voracious, demanding and threatening. The old custom of burying precious objects with the dead can be interpreted as a gesture of honour, but what about those instances where the corpse has

had its hands and feet bound? This was once understood as a sign of execution or ritual sacrifice, but many examples contradict such explanations. More likely is the idea that the hands and feet were bound not to stop the subject from resisting before execution, but, once they were dead, *to stop them from coming back*. And the precious objects accompanying them to the grave could keep them distracted. This is Picasso's universe: one where palliative measures are continually being taken to stop an evil force from wreaking revenge.

This malignant dimension is not confined to the idea of an evil eye, but the eye is certainly a privileged route for the experience of a threatening force. As we saw earlier, an infant cannot protect itself from the look of its care-givers. That is enough to give the eye an evil aspect. When works of art are from time to time attacked in museums and galleries, it is no accident that it is so often the eyes that are struck first. And it is curious that fiction has so frequently returned to the motif of the portrait that watches its spectators. Such portraits are usually of ancestors, and tend to show up with suspicious regularity in the libraries of big old houses. And, in contrast to haunted mirrors, which have a habit of speaking, haunted portraits tend to stay mute: they remain silent and menacing, to make the characters ask, 'What do they want?' The watching eyes of these portraits are almost always malevolent, and in fiction after fiction, they turn out to be the result of some unpaid debt. The ancestor was wronged or cheated, and the evil influence coming from their eyes demands that the debt be repaid.

Psychoanalysis shows the often devastating effects of the presence of unpaid debts, broken promises, thwarted desires or unsymbolized losses in the family history of a patient. These are like broken stitches in the patchwork of one's background and upbringing, and although one may be

consciously oblivious of them, they can continue to exert their lethal effects from one generation to the next. Artistic creation is sometimes a way of mollifying through sacrifice these terrible demands and invasive forces that haunt the lives of so many of us. A sacrifice is there less to please than to ward off. And it suggests that a lot of bad things will happen if the artist stops producing work. When a group of artists was asked recently what artistic production was all about, we heard the usual set of answers, until Yinka Shonibare observed that it was a way of staying out of hospital. That is, a way of stopping a lot of bad things from happening. But how could we reconcile this with the traditional psychoanalytic theory of sublimation, the idea that artistic creation is an eminently successful way of resolving conflicts? Perhaps by arguing that in fact the only people who don't sublimate are artists.

Sublimation is an alchemical term. It meant the action of heating a substance to vapour and then cooling it to solidity again, to produce a purer, more refined product. In other words, it was an action that resulted in something new, a definition that we will return to later. Nowadays, in popular culture, it is used to designate almost any successful defence against things falling apart. The classical view, however, goes something like this: sublimation is about a drive that has been diverted from its sexual aims. Instead of fucking, you go and paint a picture instead. As George Boas put it, in an exemplary misconstrual, 'An artist, according to Freud, is a man whose sexual frustrations are released symbolically in pictures or statues or other works of art.'

The energy that would have gone into sex goes into something tamer, more social. This strange dogma has actually been around for much longer than psychoanalysis, and it is usually held by men. We see it today in the sportsman's idea of refraining from sex before a match or fight. The vital force contained in their sperm can't be wasted but has to be used for the other, apparently non-sexual activity. This way of thinking also has a long history, probably going back to ancient ideas about the soul or life force being condensed in one's seed. Indeed, the theory seems so natural to some people that it can even work the other way: Balzac's wife was famously jealous of her husband's descriptions of nature, assuming that the sexual interest that should have been destined for her had been cruelly diverted into the care of his prose.

Applied to women, this dogma often takes another form. To paraphrase Boas's formula, 'An artist is a woman whose maternal frustrations are released symbolically in pictures or statues or works of art.' Assuming that all women want to be mothers, any deviation from this route is interpreted as a sublimation of maternal frustration. Such a view, of course, tells us more about the men who hold it than about the women it is applied to. As the writer George Sand replied to a Brittany deputy who instructed her, 'Don't make books, make babies': 'You should follow your own advice, if you can.'

Although these views of sublimation are caricature, the misunderstanding they involve is often present in the more sophisticated theories. What is this misunderstanding? It's very simple and consists of the idea that human beings have some basic, original sexual instinct that has to be redirected, tamed or modified in whatever way. Yet in fact Freud's invention of psychoanalysis rests on exactly the opposite thesis: that there is no such primary sexual instinct. Men, for

example, might think with their dicks, but unfortunately dicks usually think in ways that are utterly unknown to men. Even the Early Fathers of the Church realized that the genitals seemed to have a mind of their own, deciding habitually to disobey their masters. Sexual performance could become a perpetual reminder of the fact that man had sinned and was therefore no longer master of even his own body.

Freud had another version of this asymmetry. Sexuality, he thought, involved not instincts but drives. An instinct is an inherited pattern of knowledge. An animal, for example, might know how to find food, defend itself and seek shelter without any prior instruction. This sort of instinctual *savoir-faire* is displayed by most animals, and it is amazing to see the lizards that, as they emerge from eggs laid in the sand at the centre of an island to protect them from predators, instantly rush off in the direction of the seashore where their sustenance and livelihood are situated. They seem to know right from the start what to do, and it is this character of instinct that Freud was wary of applying to human sexuality. In fact, although the German term *Trieb* ('drive') is ubiquitous in Freud's writings, he uses the word *Instinkt* ('instinct') sparingly in only five of his works.

Sexuality for Freud is not an instinct but something that is constructed, moulded by words, images and signs. Although we are born with biological needs, these needs are shaped and interpreted by our care-givers. They are given meanings. Our need for food, for example, will be caught up in the ways our care-givers think we should be fed, and their own unconscious fantasies and desires about feeding. Drives are born out of this encounter between our needs and the language of our care-givers. They have their source in the body, and psychoanalysis lists four of them: the oral drive,

the anal drive, the scopic drive and the invocatory drive. They are all sexual, since they involve the surfaces and edges of our bodies, but there is no sexual drive as such that would aim exclusively at intercourse.

Drives don't have as their object another human being but a part of the body. They are partial. Partial in relation to the mythic existence of a sexual instinct and partial in relation to the mythic existence of a complete partner. Groucho Marx once wrote a book called *Beds* and gave a catalogue of all the things that go on in them apart from fucking. This was like an updated version of Freud's *Three Essays on the Theory of Sexuality*, a list of what prevents people from ever truly encountering their sexual partner. We are interested, for Freud, less in people than in the edges of people, the erogenous zones and bodily margins where our real satisfaction is situated. We are drawn, after all, to the little details in people that cause our desire.

When the *Mona Lisa*'s abductor had been apprehended, the investigators were intrigued to find ninety-three letters from a certain 'Mathilde' stored carefully in his lodgings. As they pursued their inquiries, the story of a romance began to take shape. Some time before divesting the Louvre of Leonardo's painting, Peruggia had been enjoying a stroll in the Jardin des Plantes, where he had chanced upon a fellow Italian in the company of the beautiful Mathilde. After they had dined together and then gone on to a dance in Les Halles, a quarrel broke out between the two lovers, leaving Mathilde with a knife wound in the chest and her partner vanished into the night. Peruggia cared for Mathilde and, as she recovered, her affections turned to the one who had saved her. When the tabloids commented on her radiant beauty in the wake of the police investigation, one detail

seemed to stand out. When people who had known her were describing her to the journalists, they chose to single out one particular feature: her hair had been done into *bandeaux*, exactly the characteristic of Leonardo's sitter.

Was it this detail that had attracted the thief first of all to Mathilde and then to the painting itself? Although the mysteries of the culprit's unconscious will never be known to us, this coincidence of traits shows, none the less, the power of details. And a detail is not the same thing as a person, as we can see from the many appropriations of the *Mona Lisa* itself: people single out one trait from the image, usually the smile, rather than focusing on the image as a totality, as something complete. Our interest, as Freud showed, aims at parts.

Psychoanalysis has traditionally privileged four of these 'parts', linked to the four drives: the breast, excrement, the look and the voice. If we follow the Freudian argument that our sexuality aims at parts rather than at people, the misunderstandings around sublimation become clearer. Take, for example, the case of the sex researcher Alfred Kinsey. As he pursued his vast project of documenting contemporary sexuality, he interviewed around ten thousand people single-handedly, to the amazement of the rest of the faculty at Indiana University. The mistake here would be to assume that this relentless activity, although clearly sexual, was in fact a substitute for sex itself: interviewing rather than fucking. The Freudian view would suggest, on the contrary, that his sexual satisfaction was linked to the medium of the interviews itself: the human voice. This was his real sexual object. What he aimed at was thus a part rather than a person.

If there is no such thing as a primary sexual instinct, then how can sublimation be defined as a re-routing of the primary sexual instinct? This is the paradox of sublimation.

And it should make us ask the question: Where did we get the idea of the primary sexual instinct from in the first place? Why is it such an attractive idea? The answer lies in the psychoanalytic concept of a drive. As we become human, we lose something. Our needs are alienated in the language systems of our care-givers. We stop stimulating our body surface to produce enjoyment, we learn the rules of bodily conduct and cleanliness, we are taken up into the universe of signs with all its laws and prohibitions. A void, or emptiness, is thus created. Our enjoyment will then take refuge in edges, in erogenous zones which are like leftovers, remnants.

The activity of drives aims at recuperating some of this enjoyment that has been drained from the body. This is where sex comes in. Doesn't it provide the best possible *image* of an enjoyment we have become separated from? It stands in for everything we have lost in entering the human world, which is why people always tend to imagine the pre-social, pre-civilized world as one in which everyone is fucking all the time. It gives us the right image to represent an enjoyment we have no access to.

When Lacan turned to the question of sublimation, he emphasized less the myth of a sexual instinct than this idea of a zone of emptiness, of a void that is constitutive of our becoming human. If many early psychoanalysts stressed the idea of an archaic relation to the mother's body, Lacan thought that there was a dimension of this relation that could be experienced as a suffocating proximity or unbearable absence, yet could never be grasped in language and representation. It is that part of the infant's experience of

excessive stimulation or psychic pain linked to the mother that is too much for them to process, overriding their nascent cognitive and linguistic mechanisms.

If we are defining this relation in terms of the failure of our mechanisms of representation, how can we say anything about it? How can we say what it is? Lacan's solution was to define it less as some kind of positive object with qualities and attributes than as a place, a zone that is always beyond what we can represent, or symbolize, or give meaning to. Indeed, popular culture often plays on this dimension when the latest horror or science fiction films promise us some spectacle 'beyond' our imagination and our wildest dreams.

Psychoanalysis is certainly not unique in trying to elaborate some concept of a 'beyond' to our daily experience and to our systems of representation, but it is quite specific in its characterization of this zone. Since it is beyond our capacities to represent directly, it is lost to us, yet at the same time it was never something we possessed as such. For these reasons, it becomes the space into which we project images and myths of an *origin*, of something that was there first and is now inaccessible. The later prohibitions that the child is subjected to reinforce this idea, turning what is initially inaccessible into something both inaccessible and forbidden.

There are thus two sides to Lacan's concept. On the one hand, the idea of a traumatic aspect to early experience that we cannot grasp directly in terms of representations or meanings; and, on the other, the idea of an empty space created by this failure at the level of representations and meanings. If the first aspect means that we don't want to go there, the second aspect means that we are none the less drawn towards it. The empty space comes to incarnate what we are separated from, what we have lost in our passage through

infancy and childhood. Our desires will circle it, and the less we can grasp it, the more powerful its gravitational pull.

The distinction between an object and a place or zone is crucial here. It is tempting, after all, to conflate the two and say that what we are talking about is simply the mother as a lost object of desire. But things are slightly more complex, and we can turn to the world of those fictions that promise us a 'beyond' to our imagination for an example here. Apart from being devoured by monsters or diced by killers, what happens to so many of the characters in horror and science fiction? They follow cats. Even in the most suspicious circumstances and against their (and our) better judgement, they have to find their cat and, in doing so, they usually end up being devoured or diced.

Why this strange and tragic monotony? Rather than seeing the introduction of cats as merely a meaningless prelude to some subsequent slaughter, it is showing us something about desire and the terrible zone beyond it. People follow cats just like they follow what they take to be the object of their desires, but what these films show is that there is always something beyond the cat. Monsters and relentless killers are the images that we project into this zone beyond imagination, and the search for the cat invariably leads the characters closer to it. Desire, like the search for the cat, circles around this zone, to produce the combination of attraction and repulsion that qualifies, respectively, our relation to the cat and to the killer.

The tension here is between what we can represent – a cat – and what we can't represent – the ensuing horror. The fact that such films continually invent new and more gruesome creatures testifies to the effort to find an image for what, ultimately, has none. The emptiness created by the failure of language and the imagination to grasp this dimension

becomes the space for our desires. Since our desires are built up out of representations, this zone can take the form only of an empty space, a vortex at the centre of the web of representations. In this sense, it is something absolute, beyond the register of naming and predication.

Perhaps for this very reason, Lacan chose the most minimal term possible to designate this horizon of our desires: he called it 'the Thing', and the key point for the study of sublimation is that, at the level of thought and language, the Thing is a void, an empty space. We can do our best to represent it with images of invasive proximity (monsters) or of utter desolation (falling in a void), but these are only approximations, our imagination's effort to conjure up what seems closest to its own boundaries. The Thing is always beyond these boundaries, an inaccessible zone into which we project images of horror or absence. It cannot be represented as a positive, empirical object since, at the level of representations, it is less an object than a place: and when objects go into this place, they take on new and peculiar properties.

Significantly, it was at the moment that Lacan introduced his theory of the Thing that he turned his attention to art. Paraphrasing Duchamp's definition of the readymade, he defined sublimation as the elevation of an object to the dignity of the Thing, or, in another formula, as the colonization of the space of the Thing. The immediate interpretation of these formulas is that sublimation involves a removal of an object from its habitual co-ordinates, those that allow us to recognize it. An object would lose whatever it is that gives it meaning and makes it recognizable for us. And rather than obscuring or hiding the zone of emptiness, it points to it, evokes it. There is thus a difference between the object and the space the object finds itself in, the special, sacred place of the Thing.

One of the implications of this argument is that sublimation will be linked to precise historical moments, points at which there is a change in the way we see things, in the ways in which we experience reality. This is reflected in Lacan's curious choice of examples: where most psychoanalytic discussions of sublimation refer directly to well-known works of art and the biographies of artists, Lacan turned instead to the invention of the system of courtly love and then to the practice of collecting matchboxes. What the two have in common is the elevation of an object to a new status. The collector has situated the matchbox in a new space and removed it from its familiar use, and the courtly love tradition has elevated woman from being an object of exchange into a sublime and inaccessible figure.

Beyond the intriguing choice of examples, there might seem to be nothing new here: defamiliarizing an object is a staple explanation for the endeavours of art in so many modern discussions. Where the formula is original is in the linking of this defamiliarization to the idea of a zone of emptiness. The objects, it implies, point to a void that is beyond them, a void that is absolute and beyond our capacities to imagine visually. One figure of this void would be death. Discussing courtly love poetry, Denis de Rougemont noticed that it seemed as if all the poems were addressing the same person. The terms of praise, adoration and service didn't seem predicated on the specificity of any real person, even though we know that real ladies certainly existed and courtly lovers did things with them that were not prescribed in their verses. If real ladies were transformed via the symbolic code of courtly love into one and the same woman, she becomes dehumanized, and so, for de Rougemont, there is no difference between the Lady and Death. She has gone

into the place of an absolute, and the lines of the courtly lover become cultural formations colonizing this space. In Lacan's terms, she has taken on the dignity of the Thing.

Courtly love, for Lacan, is a paradigm of sublimation. Like the system of linear perspective that would be introduced into painting many years later, it is an artificial construction, and it is this artificiality that especially interested Lacan. Courtly lovers created a set of artificial barriers to separate them from their Lady, who became emptied of all substance, a cold and inaccessible figure. Just as a zone of emptiness is established by the universe of signs and language, the codes of courtly love manufactured a symbolic system and a zone that was inaccessible. What courtly love did, according to this view, was creationist: it re-enacted the structure that reality is based on and, in doing so, it created a new object – the Lady.

We can find a recent example of this creationist thread in fine art photography. Rather than capturing the usual or unusual subjects of visual reality, artists such as James Casebere and Anna Gaskell carefully create their own realities, and then shoot them. Casebere builds maquettes, usually of empty, tomb-like architectural spaces, while Gaskell constructs a baroque space of surreal interiors and exteriors, peopled by figures stacked up against the picture plane like the characters of medieval painting. Rather than claiming to record a shared, common space, they photograph created spaces that are deliberately artificial. There is no attempt to make us believe we are seeing something real, something that would encourage us to search for a model in the way that scholars used to comb Europe looking for the church interiors that would match those depicted in a Van Eyck painting.

The tension here is not between a reality and its representation, or the natural world and the world of signs. These

artists have registered the fact that the natural world is *already* caught up in language, it is already pulverized by signs. Even our ideas of 'nature', for example, are the result of complex historical and cultural processes: the way we look at some idyllic or shabby country spectacle will be informed by how we have seen it represented in art, the media and so on. But where do such representations come from? And what is beyond them? The creationist can only posit a point of *ex nihilo* here, and this is where art is so special. It can show us not simply a created object, but an object that consists in the act of creation. Artists such as Casebere and Gaskell present this point of creation to us, taking seriously the fact that we live in a world crushed by signs: hence they stage their own, individual crushings of the visual field. They take a created reality, and then show, via the subsequent creating in their photographs, how we create. Rather than using the register of the artificial to say something about the artificial, which was a basic strategy of modern art, much of this contemporary work suggests that in fact the only way to grasp the real is to access it through the artificial: through, for example, the constructed maquettes of Casebere or the bizarre spaces of Gaskell. Rather than simply trying to represent emptiness, they confront us with the creation of emptiness. And to do this means shifting the visual tension from the classical gap between reality and the artificial image to that between a reality that is *already artificial* and the image.

Although Lacan focuses his discussion of sublimation on courtly love, he does give one example of an artist, taken from an earlier paper by Melanie Klein. Ruth Weber suffers from depression and lives with her husband in a house full of paintings. These are the work of her brother-in-law, an accomplished artist, and one day he removes a particular

work. Weber is confronted with what she describes as the experience of an empty space, the picture's absence having a polarizing effect on her depression, which now becomes more severe. Note that this empty space wasn't there before the paintings: it is not something original, primary, but is produced by the change to the arrangement of objects. If it is a void, it is a manufactured void. Now, not long afterwards, she starts to paint, producing first of all a portrait on the wall in the very place where her brother-in-law's picture had been. She does all this in such a dazzling and successful way that the brother-in-law can't believe that she is the real author of the works.

This no doubt idealized story shows a pattern: a gap is made by the network of signs, and an artwork is generated from this gap. Beyond the work of art is the void that it is based on and evokes. Although this story suits Lacan's purposes very nicely, he is sceptical as to the facts of the case and, indeed, it turns out that the narrative that Klein used was somewhat fantastical. Weber was certainly prompted to paint by the sudden emergence of the empty space, but she did this on canvas, not on a blank wall, and she received instruction on technique prior to this from her brother-in-law. Creation *ex nihilo* there might have been, but in a somewhat less miraculous form than the initial fable suggests.

Lacan's discussion of sublimation here returns frequently to the image of the potter, someone who, quite literally, manufactures an empty space. There is thus a certain serendipity in the discovery of the painting that Weber produced that day in 1928: thanks to the help of her relatives, it was possible to identify it as the portrait of Josephine Baker reproduced below. Although neither Lacan nor Melanie Klein had seen the picture, they knew that it was a

nude, as a newspaper article by Karin Michaelis entitled 'The Empty Space' had made clear. Lacan's references to vases and pottery in relation to this empty space become uncannily precise when we see that what Baker is gazing at is a huge, empty vase.

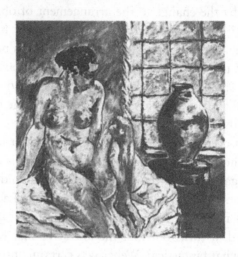

Do these thoughts about emptiness help us to understand why everyone went to see the missing *Mona Lisa*? As one French newspaper recorded, when the Louvre re-opened, '[The crowds] didn't look at the other pictures. They contemplated at length the dusty space where the divine *Mona Lisa* had smiled only the week before. And feverishly they took notes. It was even more interesting for them than if the *Gioconda* had been in its place.' If we follow the Lacanian argument, the crowds that flocked to the Louvre after the theft of the *Mona Lisa* demonstrated the true function of the work of art: to evoke the empty place of the Thing, the gap between the artwork and the place it occupies. As one paper put it, commenting on the crowds that converged on the

empty space, 'Some people like works of art for themselves, others for the place they occupy . . .' And this place, for *Le Figaro* at least, was 'an enormous, horrific, gaping void'.

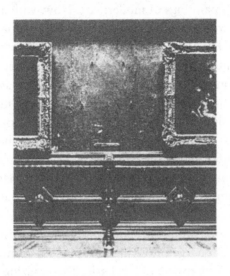

In a sublime parallel to the story of Ruth Weber, the removal of a picture actually resulted in a multiplication of artworks for the Louvre. In 1907, the roguish adventurer Honoré-Joseph Géry Pieret was wandering around the Louvre, and, realizing how easy it would be to snaffle one of the works, tucked an antique head under his coat and left. Soon afterwards, he tells the painter Marie Laurencin, Apollinaire's lover, that he is off to the Louvre and asks her if there's anything she wants. Laurencin wasn't especially scandalized by the question since she assumed he meant the Magasin du Louvre, a popular department store on the rue de Rivoli.

When Géry Pieret returned, he had with him an Iberian head that he very soon, together with the first one, sold to

Picasso, who had probably already expressed his interest in these works. According to several commentators, these heads would resurface in the *Demoiselles d'Avignon*, one of the defining paintings of modern art. Now, with all the publicity a few years later around the theft of the *Mona Lisa*, the newspaper *Paris-Journal* offered a substantial cash reward for the painting's return, an offer that Géry Pieret decided to capitalize on. He turned in a third head he had stolen a few months earlier, and indicated that there were more where that had come from. Since Géry Pieret was soon traced to Apollinaire's flat, where he had been staying, the poet and Picasso, who still had the two Iberian heads, began to panic. At any moment the trail was going to lead to them.

After some rather comical efforts to divest themselves of the heads in Picasso's possession, Apollinaire turned them in to *Paris-Journal* and, sure enough, was soon arrested himself on the initial charge of having harboured a criminal – Géry Pieret – who by now had left Paris. The amazing revelation of this whole episode is that, although the Louvre had now secured the return of its three heads, no one had noticed that they were missing in the first place. It took the theft of the *Mona Lisa* for people to start realizing that all was not what it seemed at the Louvre: and, significantly, it was the empty space created by the absence of Leonardo's painting that would produce the miraculous appearance of other works of art. Like the pictures painted by Ruth Weber, the antique heads emerged from the creation of an empty space.

Was the theft of the *Mona Lisa*, then, the perfect crime of the Modernist era? A painting is stolen, and thousands converge on a museum to see an empty space. The crime seems to herald so many of the preoccupations of both the artists and the writers of Modernism: the powers of absence, the

void beyond the image, the emptiness at the heart of civilization. This is perhaps the reason why the arrest of Apollinaire seemed so logical to so many: wasn't he the advocate and self-proclaimed spokesman of a movement that turned on just these principles, the man who had been overheard urging the destruction of the world's museums and the paralysing powers of the past?

And doesn't the theft set out an agenda for the practice of art in itself? The split between the work and the empty place it occupies is arguably a defining feature of seminal, programmatic works such as the *Black Square* of Malevich, shown only a couple of years after the return of Leonardo's painting and consisting simply of a black square on a white background. The tension between a painted image and the place where this image is housed thus becomes the very subject of the work of art.

Peruggia's act was thus more than a simple theft. It set the scene for a century in which people would go to museums and art galleries to 'see' the emptiness that modern art offered them. The theft, in this sense, must be included in the list of the great, defining works of the Modernist movement – a movement that Gertrude Stein had characterized in terms of the uneasy cohabitation of pictures and frames. In a sentence that purported to describe Cubism but in fact applies equally precisely to the *Mona Lisa*'s theft, she wrote that this was the era in which 'pictures commenced to want to leave their frames'.

And indeed, the theft both allowed and precipitated a new circulation of images: the *Mona Lisa* left her frame to become scattered in a panorama of media, from cartoons to sketches and cinema. When she reappears as a detail in Malevich's *Composition with Mona Lisa* (1914) or Leger's

Mona Lisa with Keys (1930), her presence testifies to the newfound possibilities of quotation. Although such practices may be traced back to earlier currents in the history of art, isn't there an interest in seeing in them one effect of the *Mona Lisa*'s sudden dispersal? The image of a revered and iconic work, once it had vanished, could pop up just about anywhere: although it was now set in celebrity, it had lost the anchor that its frame had symbolized. It acquired a new lightness. The reappropriation of classical images that is such a feature of modern art thus has a special debt to Peruggia and the empty space he created on that hot August morning in 1911.

Pliny provides us with another example of the powers of emptiness. In the *Natural History*, he tells us that Appeles visits the studio of the painter Protogenes and finds a panel on an easel ready for painting. In the absence of the artist, he leaves a calling card in the form of a fine line painted right across it. When Protogenes returns, he sees the fine line and just how fine it is, and guesses the identity of his mysterious guest. Using another colour, he then paints an even finer line on top of the first one, and instructs his attendant to show it to the visitor when he returns. Appeles comes back, sees the new line, and cuts it with another line again in a new colour, even finer. And so, Pliny says, Protogenes finally admits defeat.

This vignette, like that of Zeuxis and Parrhasios, shows us how art history is just as much to do with the competition between artists as the composition of works of art. Yet the fate of the panel is even more instructive. Pliny adds that it was burned in the first fire to strike Caesar's palace on the

70

Palatine: 'It had been previously much admired by us, on its vast surface containing nothing else than the almost invisible lines, so that among the outstanding works of many artists it looked like a blank space, and by that very fact attracted attention and was more esteemed than any masterpiece.' Thus Pliny gives an account not only of the birth of abstract art but also shows how the work takes on its peculiar power through the production of a central zone of emptiness. The crowds went to see it, like Leonardo's missing painting, because of the evocation of what wasn't there.

Although Pliny's reliability as a historian is generally open to question, the fate of this anecdote testifies to the difficulty in recognizing the powers of emptiness. Where Pliny quite clearly refers to lines, later commentators insisted that he must have meant contours and drawings of limbs or bodies, or even an early system of perspective. And as one eighteenth-century French writer put it, Pliny should have known better than to repeat such a story, as the notion of 'a panel that looks empty but is admired, especially by artists, is an unimaginable thing'. *Inimaginable* – exactly the term that *Le Matin* newspaper would plaster over its front page almost two centuries later when Leonardo's panel vanished from the Louvre.

This creation of a zone of emptiness is not something that is confined to Western art. Take, for example, the use of screens in Chinese tradition, used both as partitions and as surfaces for the painted image. When we see the depiction of mountains and lakes on a screen placed beside a group of people with a 'real' background of mountains and lakes, we can wonder what exactly the screen is doing there. The immediate interpretation would be that since the painting is itself on a screen, the screen-within-a-screen is suggesting the

fact that nature is already caught up in the world of signs. Painting does not take us to nature, since nature is already a painting. But this is not the whole story. In one well-known anecdote, Sun Liang commissions the manufacture of a fine glass screen. On cool and clear nights, he sets the screen up in the moonlight and invites his four favourite concubines to sit inside. 'Watching the ladies from outside,' we are told, 'there seemed no separation between them and the guests; only the women's perfume was sealed inside.'

Now, it turns out this kind of glass screen could not have existed in the third century, and so, as the art historian Wu Hung asks, the question becomes why anyone could have imagined one. Since it did not obstruct one's view it could not fulfil the screen's most obvious function of creating an opaque enclosure. As Wu Hung points out, 'although the line between *interior* and *exterior* had become invisible, the separation between the spaces was still there'. The screen thus created a zone of emptiness in the apparent continuity of the visual world. Even if it was transparent, according to Wu Hung, what Sun Liang showed with his screen was nothing less than the function of painting itself: what he displayed to his guests was not his concubines but their 'live images' framed by the transparent screen. The screen had marked out an inaccessible zone, and then colonized this zone with the image of woman. And like the Lady of courtly love, she remains at an artificially created distance.

This accent on artificiality can give us a clue to the notoriously thorny question of prehistoric art. There always seems something slightly awry with efforts to map a continuum from drawings of mammoths to the latest in contemporary art, as if they all formed parts of the same story. The vicissitudes of religious art, the creation of the art market and the

relations of art to capitalism, for example, introduce very profound discontinuities into the place civilization gives to images. Likewise, the consideration of prehistoric artefacts tends to give a green light to the most fanciful kind of speculation, as we can see in the various attempts to explain such objects and images from an evolutionary perspective.

The more traditional explanations of cave drawings fall more or less into two groups: those that posit a kind of primitive accountancy, where the drawings record the triumphs of a hunt and the number of hits, and those that find in these productions an art for art's sake, the manifestation of a pure aesthetic sense. Both of these perspectives have their problems. Note first of all the frequency with which the outlines of the depicted animals contain, or are broken by, single lines. These lines are usually interpreted as arrows, or notches recording the number of kills. And yet these notches have often all been made at the same time, and cover the whole surface of the animal or its border. The accountancy model fails to explain this feature, as well as the existence of the many pictures that do not seem to depict hunt-related activities.

The art-for-art's-sake model is more interesting, but runs aground on the problem of the poor visibility of the drawings, which are often situated in the most inaccessible parts of a cave. Lacan's idea of a zone of emptiness, however, allows us to interpret these productions in a new light. Aside from the fact that the vault-like interiors of such caves may evoke this emptiness, the key lies in the artificial additions to the rudimentary forms of the animals and humans depicted. What makes much of cave art so striking is the presence of the lines that break the continuous boundaries of its figures, and whatever interpretation we give to the *meaning* of such

lines, they are clearly situated *in a different register* from that of visual form. Whether we interpret them as numbers, messages or arrows, they embody the intrusion of another, more abstract dimension into the visual world. And, in that sense, they embody the intrusion of language, of the signifier.

Doesn't this allow us to bypass the old problem of trying to reconcile the figure drawings of the prehistoric period with the so-called decorative arts? Alongside the mammoths, we have objects and tools that have been marked with lines and notches, to produce patterns. Since such artefacts do not seem to be 'art', the decorative dimension is often separated off, to give histories of design which are partitioned off from histories of art. Yet what the drawings and the objects have in common is the imposition of lines and marks, that is, an intrusion into the register of forms of something that separates space, makes space discontinuous. Isn't there an interest in seeing figure drawing and design as strands of the same effort to show how the symbolic system imprints itself on the human world? And doesn't this suggest that a basic concern of art is with the effects of symbolic systems on the world of visual forms?

All human groups make marks on surfaces. Doing this creates differences: objects become separated off from others, they become symbolic of rank or prestige, they become more valuable or they take on other, specific functions. Marking thus introduces symbolic systems, where each object takes on its value in relation to a network of other objects. Such systems, of which spoken language is the privileged example, are imposed on human beings from the moment they are

born, and no doubt even before. The desires and fantasies of parents precede their children, and simply to say 'It's a girl' or 'It's a boy' brings with it all the assumptions, suppositions and ideals a parent might have about the meaning of these terms.

We are born into a universe of signs and, from a psycho-analytic perspective, one of its main effects is the experience of loss: the loss of the mother through the prohibitions of the Oedipus complex, the loss of the body's enjoyment through the constraints of education, and the different forms of loss involved in the assumption of speech and language. And loss creates desire, the yearning to re-find something we believe we once possessed. Art provides a special place within civilization to symbolize and elaborate this search.

On an immediate level, a painted surface points to something beyond itself; it marks out an inaccessible zone. Many of the myths about the origin of painting, from Pliny to the Renaissance, link it to the act of outlining a shadow, and thus, in one sense, framing an absence. A shadow, after all, cannot be grasped, and it lacks the substance of a body. But, equally significantly, artworks inhabit privileged spaces, from the recesses of caves to the niches carved out by the art market. Just as the lines and markings that cut the contours of forms in archaic art make these forms *different*, so too the place the art market gives to works makes them unique, different from anything else. They inhabit a special space.

In Lacanian terms, art objects go into the place of the Thing, which can never be represented as such, only evoked as a beyond. There will thus always be a tension between the work of art and the place it occupies, and it has been argued that modern art aims to preserve the minimal gap between the place and the element that fills it. Where many saw the appearance of Duchamp's readymades as signalling the

destruction of art, this view suggests that they simply drew out its basic structure, the tension between a work and where the work finds itself. Hence the crucial significance of Malevich's *Black Square*, a work that is no more than the contrast between the white background – the place – and the black square – the element that inhabits it. And as traditionally taboo sexual objects can be represented today without too many problems, the idea of a 'beyond' is reduced to something purely formal. What matters is keeping a distance between the work and the place it occupies.

The psychoanalytic approach here explores art structurally, rather than in the more traditional, interpretive way of the early Freudians. With Malevich, for example, it is the tension between figure and ground, between element and place, that matters. This certainly tells us more about art than psychobiographical approaches, but it is tempting to add an anecdote here from the Russian painter's childhood: as a boy, Malevich would watch his father at work in a sugar factory, and was fascinated by how the dark, raw molasses would be fed into machines to emerge as a white, crystalline substance. But then, we might ask, why wasn't his initial square white and its background black?

In his development around these themes of element and place, Slavoj Žižek finds a logic in the elevation of trashy or excremental objects to the status of art. When we see junk or excrement in an art gallery, the first reaction of many people is: 'Is this art?' For Žižek, this shows that rather than focusing on the work, such art draws our attention to *the place the work occupies*: asking if a piece of junk or excrement is art only goes to reaffirm the separation between the work and the place the work finds itself in. Rather than undermining this separation, such currents in art would

constitute a desperate attempt to show that the sacred place of the Thing is still there. For Žižek, many of today's artists are thus trying to save the logic of sublimation, the minimal gap between the element and the place – the very gap that the theft of the *Mona Lisa* brought so spectacularly to public attention.

Can this tension between element and place tell us something, in turn, about the internal dynamic of Leonardo's painting? There is certainly something quite strange about the background to the female figure: the rocky crags and landscape are not entirely unconventional, yet the two halves on either side of her fail, conspicuously, to meet up. There is a lack of symmetry between them which has often attracted the attention of viewers. Contemporary art theory stressed the separation of figures from the *campi* of background architecture and landscape, and these latter sections of a picture were often added by the artist's workshop or specialized draughtsmen: indeed, fifteenth-century workshops often kept stocks of landscape drawings to be inserted into the backgrounds of narrative paintings.

In contrast to this apparent devaluation of background, so central was the actual figure itself that one fifteenth-century contract specifies that 'the empty part' of the picture had to contain landscapes and skies. Indeed, for Vasari, the relation of figure to background was defined as a relation between figure and void. The painting, in these terms, contained its own empty space.

Although this space is occupied in the *Mona Lisa*, the discrepancy between the two halves of the background landscape draws attention to it, and offsets the apparent verisimilitude of the figure herself. Why should this 'real' lady inhabit such an unreal landscape? The point here isn't

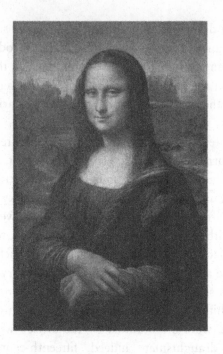

the detail of the landscape itself, as such unreal scenes follow artistic convention, but rather the lack of symmetry. We can find the same failure to cohere in Lorenzo di Credi's *Annunciation*, where the background sections seem to be situated on different levels.

The enigma of this split landscape is more mysterious, perhaps, than the *Gioconda* smile itself. Even if it turns out that some arcane symbolism or theory of microcosm and macrocosm lurks in the split levels, the immediate effect is that of a discontinuity in the visual field, as if beyond the lady is a crack, a faultline in visual space. Her figure functions as the threshold of this impossible background, framing it and evoking it as a beyond.

Although Freud has a lot to say about the painting, he

avoids the question of the background's inconsistency even though it fits quite nicely with some of his theories. In the Leonardo book, he adds a new twist to his earlier idea that we want to look at things because of the genitals we don't see. The boy gives a certain importance to his penis, and cannot believe that it could be missing: hence he endows everyone, including his mother, with an organ like his own. 'That the penis could be missing', Freud writes, 'strikes him as an uncanny and intolerable idea . . .' When he registers the fact of female anatomy, he assumes there is a penis that will grow later and, soon afterwards, that it must have been cut off at some moment in the past. But prior to these developments, Freud thinks, the boy will have an intense desire to look, to search for the genitals.

Freud uses these ideas to give voice to the infant Leonardo: 'There was a time when my fond curiosity was directed to my mother, and when I still believed she had a genital organ like my own.' Now, whatever we make of the biographical evidence for this in the case of Leonardo, the implication of Freud's argument is quite radical: it's not that we look for something that society forbids us seeing, but that we look for something that, since it doesn't exist, is strictly speaking *impossible* to see.

This might seem odd, but it is in no way contradictory. What, indeed, could characterize human endeavour more than the idea of striving for something impossible, something that never existed in the first place? When we are presented with what claims to be everything, there always seems to be something missing. If much earlier art depicted the human body veiled and obscured, more recent attempts to lift the veil, to show everything, from the genitals to the internal organs of the body, still leave the appetite of the eye

unsatisfied. It's not that we are being prevented from seeing something, but that there is something that cannot be seen as it lacks a visual image. Hence it can be evoked only as a beyond. In this sense, the landscape background to Leonardo's painting functions as an immense veil, evoking for us the basic impossibility that Freud describes.

This impossibility is explored in the work of Sarah Lucas. Everyday objects, fruit and vegetables all combine to give the form of the sexual characteristics of men and women. The body seems reduced to the primary, defining features of protrusions and openings. No external object, it seems, can fail to be sexual. But when it comes to the reality of the genitals themselves, when we expect the great unveiling, rather than finding the graphic image of sexual organs, we just find more symbols. And these symbols are more sexual than the genitals themselves. If the work with fruit, vegetables and all manner of objects suggests that everything is a sexual symbol, Lucas's photograph is showing us that the sexual organs are a sexual symbol as well.

It's not that we will find a hidden sexual reality behind the symbols, but that this hidden reality is just more symbols: the body is reduced to a sort of skeleton of symbols. In this sense, the 'real' sexual reality is always elusive; we can never pin it down or visualize it. We are less in the register of the early Freudian view that visual reality is based on the exclusion of something that *could* be represented, than in that of the later view that what we aim to see can *never* be seen, as it doesn't exist.

If we take Freud's argument seriously, this means that the visual field is always incomplete: there is something that we cannot see, yet that we are looking for. If visual art has a special relation to this dimension of loss, there will always be something 'beyond' a painting, however graphic or detailed it might be. Indeed, this belief is echoed in one of the most fascinating responses to the theft of Leonardo's masterpiece. When the newspaper *L'Echo de Paris* ran its story of the theft, hundreds of readers wrote in offering their own solutions to the mystery of the painting's disappearance. After the initial excitement at the sheer volume of correspondence, it noted that in fact most of these letters were saying the same thing: that the *Mona Lisa* had never left the Louvre but must have been hidden behind some other painting in the collection.

This strange congruence of voices demonstrates less a shared rationality than a belief that there must be something 'beyond' the painted surface of a work of art. In Freud's terms, if the object we search for does not exist, we'll keep looking, and if a painting or work of art can evoke for us the idea of something hidden, we will be even more interested. Any art form that accentuates the idea of a surface that we cannot see beyond will be ideally suited to catch our desire.

The surface is like a veil, evoking a beyond yet withholding it: how else, indeed, could one point to an object that has no existence except by means of the veil in front of it?

If, to take another example, something is left out of a painting, we will want to see more, since it stirs up in us the desire to see what by definition can never be seen. The history of art might even be understood as the history of finding different ways of leaving something out of an image. We could evoke, for example, the moment when it became possible to include half-seen objects or figures in a composition. Whether the object in question was a farmyard animal or a female body, seeing only a portion of it would excite the eye to see more. Ernst Gombrich pointed out that such techniques radically transformed the notion of what a picture was all about, since half-seeing is closer to our experience of visual reality than the contemplation of 'complete' forms.

While agreeing with the idea that the inclusion of half-seen figures was radical, it is questionable whether the same criteria apply to so-called experience: the idea of seeing half an object probably began in art, rather than in everyday visual encounters. Even so, the artistic innovation follows the logic of the look: we are drawn to what cannot be seen. When Robert Rauschenberg took a picture by Willem de Kooning and then erased it, calling his new work *Erased De Kooning*, he was playing on this principle of absence. To Rauschenberg's *Erased De Kooning* could be added the title the Louvre omitted to give to its new space in the Salon Carré: *Missing Mona Lisa*.

This emptiness evoked by the work of art is why we have to pay so much money to have one. When people mock the art world, they often ridicule the fact that an everyday object or arrangement of objects takes on a huge price tag if it is

signed by the right person. When Warhol placed an ad in a newspaper in 1966 that he would sign anything brought to him, including money, his act perpetuated what, for some, it apparently undermined. And yet how could anyone who valued their sanity pay hundreds, even thousands of dollars for a Coke can? But the real question here is to ask *where else* in civilization one can pay so much money for so little.

After a conference abroad, I was invited with the other speakers to spend the evening in a hostess bar. The drinks were exceedingly expensive, but when the bill came the tab was not just exceedingly large. It was beyond description. And everyone was still sober. As the hosts scrutinized the sums, the apparent error was explained. The Cokes had been charged at the equivalent of several hundred pounds each, and the small print on the bar menu spelt everything out clearly: if a hostess ordered a drink herself, a special price list was introduced. And on this special price list, a Coke cost what was probably at least several months' wages of someone working in a Coke factory. We have here a kind of inversion of the famous story told about Picasso's visit to a restaurant. When the bill was presented, the manager proposed that perhaps the artist could doodle a little something as recompense for his meal. Picasso replied that he merely wished to purchase his dinner, not the whole restaurant. In our example, on the contrary, the guest is asked to purchase the restaurant, yet certainly not for himself.

The vastly inflated tab makes sense. It confronts us with the fact that we have to give up everything for nothing. The absurd price simply made manifest the gulf between the world of images – embodied here by the actuality of the soft drink – and the world of signs – embodied here by the arbitrary price. No symmetry exists between these registers, as

the cave paintings we discussed earlier perhaps show. That is what reality is all about. To inhabit reality, we have to renounce something and let the register of signs and symbolic values mould and structure everything else: mammoths get criss-crossed with lines, and the same Coke that costs a dollar at one moment costs hundreds of dollars at another. Since that is what the real world is all about, we don't notice the principle behind it, until something happens to remind us of the void that the symbolic system has created. Into this void we project the image of woman, and it is no accident that our example comes from the world of adult bars where the hostess is supposed to be inaccessible.

It is not that a woman is prohibited for us, creating a zone of emptiness, but that we put the image of the woman into that space which has been produced by the world of language. If Lacanians would refer to castration here, it evokes less the woman's inaccessibility than the gulf that separates 'natural' objects and images from the symbolic universe. And that is why art is so expensive. It evokes our castration, the fact that everything has to be given up for nothing, but here in a form that is *sanctioned* by civilization. The art market exists as a kind of installation within civilization to remind us of what happens to make civilization possible in the first place. The gulf between money and objects is not a symptom of the art market but its condition of existence.

Although it might seem an odd comparison, art has a lot in common here with jokes. In the years when psychoanalytic approaches tended to focus reductively on biographical details, Gombrich once suggested that the best place in Freud's work from which to start thinking about art was his book on wit. A joke, for Freud, relied on a complicated mix of a message or 'tendency' (hostile, sexual, etc.)

and the formal structures of language, the linguistic mechanisms that would give the joke its form. A pun or *double entendre* relies, for example, on what a language has to offer in the way of similarities between words. These resources of language can be exploited or brought out by the person telling the joke, but they are not invented as such.

In the same way, a work of art could have its 'message' or 'content', perhaps linked to the artist's biography but, crucially, this would be moulded, shaped and structured by the formal syntax of the contemporary language of art. Rather than seeing artistic form as merely the vehicle of the artist's unconscious thought, Gombrich argued that Freud's theory of jokes showed how, as he put it, 'It is often the wrapping that determines the content . . . The code generates the message.' Although Gombrich did not develop this idea in any systematic way, it is a brilliant insight, bringing together two radically disparate human phenomena in a way that illuminates both of them.

From a Lacanian perspective, the comparison is equally fruitful. Lacan thought that jokes are about our relation to language, in the sense that language not only gives form to but distorts our original intentions. To speak, we have to use codes that are imposed on us by our care-givers and their language. In this process, part of what we 'mean' to say is always lost, and jokes involve a privileging of this dimension of meaning 'in between the lines' that is actually sanctioned, recognized by the code itself. The code scrambles our message, but at the same time gives a place to this scrambling in the form of jokes. A joke, in this sense, is a message about the code. In the context of our argument about art, what a joke and a work of art have in common here lies in this factor of a system housing a special place for the presentation

of what the effects of the system are. Civilization sanctions art as a kind of message about itself, about the loss that makes it all possible. And hence, as Martin Kippenberger once pointed out, art is like a running joke.

This implies that there will never be agreement about whether new, fresh artworks should be taken seriously. In our culture, the gulf between money and objects produces the idea of the priceless work of art, and it is significant how so many popular representations of the art lover make him – it is almost always a man – someone who has everything. He has everything except a work that he loves, and so, quite naturally, he sets about stealing it. The art thief, in this genre, is always rich, so that the artwork that he doesn't have comes to represent that which is beyond the register of tradable, price-tagged objects. It becomes an object of desire *par excellence*, something absolute that cannot be subject to laws of exchange.

In this respect, there is a certain proximity between the artwork and a woman: and don't we find, in so many popular films, from the remake of *The Thomas Crown Affair* to *Entrapment*, that the same question that is asked about the work of art is also asked about the woman: Is she a fake? To what extent the characters played by Rene Russo and by Catherine Zeta Jones are bluffing is a question that touches the paintings that they become involved with.

These films tend to be about male desire. A man who can buy everything feels that he is missing something. And in the place of this something is an image of beauty: a painting and/or a woman. The question of whether the artwork or the woman is a fake is a way of expressing the fundamental uncertainty as to whether any empirical object is the answer to what they want, just as Zeuxis' grapes may be fed on by

the birds but will never satisfy them. Since desire is a state that involves the lack of an object, the idea of satisfying desire with an object is a contradiction. This means that both the painting and the woman will be tainted with the thought: 'That's not it.'

And the priceless nature of the object in these films shows that the mirage of the object of desire is always situated beyond the market of circulating values and goods. As an absolute object, the question of its reality, its authenticity, *has* to be raised. Hence the motif, in a film such as *Entrapment*, of whether a human being can be bought, whether money can make them give up their desire. As Freud had argued, the ultimate object never existed to start with. It is an empty place into which we project certain images, and the doubts about an object's authenticity serve to accentuate this difference between an object and a place. An artwork – or the image of a person – may go into this place, but it cannot become identical with it. The object and the place the object goes into are separate, and when an object seems to become special, different from everything else, the question of authenticity will always emerge.

This suggests that new, innovative art will always bring doubts about its authenticity and, in fact, this is just what we see with the story of the *Mona Lisa*. When the painting was stolen, it was proposed that the purloined object was a fake anyway, having been spirited away secretly some years before. And when it returned to the Louvre, many stories circulated that it wasn't, in fact, the real thing. Rather than seeing these hypotheses as fruitless speculation, why not interpret them as structural consequences of the necessary gap between a place and the element that fills it, between the void of desire and any object that claims to satisfy it?

Something will always remind us of this gap between object and place. And if, for Freud, the place is that of an object that never existed, how can any empirical object fill it?

In contrast to the films we have been discussing, the art thief of the last century turned out to be penniless. When Vincenzo Peruggia met the Florentine antique dealer Alfredo Geri in December 1913, claiming to have the *Mona Lisa* in his possession, he told him that the masterpiece was at his lodgings, a cheap hotel in the via Panzani. And there it was, in a cheap trunk, beneath a pair of cheap shoes, a cheap shirt, some cheap woollen underwear and another pair of shoes bought for a hundred sous that his cousin's wife had given him to take to her mother.

Peruggia had been born in 1881 in a small town in northern Italy, and had received hardly any formal education. In fact, not knowing that Leonardo's painting had been taken by the artist himself to the court of Francis I in France, he assumed it had been stolen by Napoleon and his mission was therefore to return it to its source. It had remained for more than two years in his trunk in a dismal boarding house in Paris before travelling with him to the city in which Leonardo had painted it. Peruggia was hardly Thomas Crown: all he had in his pockets when the police arrested him was one franc and seventy-five centimes. No flash cars, no fine wines, no hi-tech equipment, no beautiful woman as accomplice. Just an itinerant house painter who chose this picture because, he said, it seemed to be the most beautiful.

Peruggia's insistence that he had taken the painting in order to restore it patriotically to Italy was weakened by the fact that he had asked Geri for a half a million lire for it. The painting certainly had a price, but not the one Peruggia bargained on: what he got for it in the end was a year and

fifteen days, commuted to seven and a half months since he had been locked up already since December. Geri himself felt short-changed. He had received a 25,000-franc reward and a minor honorary title, but this wasn't enough. Since the finder of a lost object was supposed to receive a reward of at least 10 per cent of its value, he decided to take his claim to the courts. In the end, the only people to get any richer were the lawyers, and Geri was told that he had merely been performing his public duty in handing over the piece and, anyway, how could you calculate 10 per cent of what was priceless?

If emptiness is so important to understand the function of art, does it matter in the same way for everyone? And is it always the same kind of emptiness that is at stake? As we shall see, this is far from the case. In fact, the theory of emptiness and the void seems to make more sense to explain the place and the value of works of art in civilization. The process of artistic creation is obviously linked to the way in which society receives the artist, but it is not the same thing. If a painting can evoke the empty space for us as viewers, its role for the artist may be quite the opposite.

An autistic child I worked with would paint incessantly. It was the only activity that had any interest for him, and yet he wasn't in the least bit concerned with his paintings once he had produced them. He would paint mechanically, and after a while it became apparent what he was really preoccupied with. He would frequently become agitated, not necessarily at moments when a picture was finished or unfinished, but according to whether the paint pot was empty or

full. What mattered to him was less to make a picture than to create an empty paint pot.

Trapped in a world where everything impinged on him too much, where there was no empty space, his artistic activity involved the effort to create a void. Since no one else was doing it for him, he had to do it himself. Where Ruth Weber created *from* an empty space, this child tried to create the empty space that had never existed for him. And can't so much artistic production be situated in the same register? As Paul Klee once said, speaking of Mondrian, 'To create emptiness is the principal act. And this is true creation, because this emptiness is positive.'

Positive emptiness is perhaps what is missing from the world of autism. Psychologists have produced a vast literature on the question of so-called object constancy, the ability to recognize the endurance of an object once it is removed from our field of vision. At what moment, for example, does an infant search for a toy that has been hidden under a cushion or track its movement behind an opaque screen? What seems clear from such studies is that looking is activated by disappearances: vanishing objects make us look for them. As we saw earlier, we get interested when something is lost.

When Piaget began investigating these matters, he was puzzled by an odd phenomenon. His nine-month-old son was placed on a sofa in between a coverlet and a piece of clothing. When Piaget removed his watch and placed it under the coverlet, the boy lifted it to uncover the object. This was repeated a few times. Then Piaget put the watch under the piece of clothing, as his son watched him carefully. But rather than lifting the garment, the boy now lifted the coverlet once again. Although this may be understood as a developmental 'error', as if he wasn't yet old enough to

understand about object constancy, one might argue, on the contrary, that Piaget's son had in fact grasped the fundamental point about human desire: that there is a difference between an object and the place the object occupies. When he lifted the coverlet, wasn't he aiming at the place that had now, due to the change in the watch's location, become its original empty place? He was less interested in the watch than in the place the object had occupied. Just like the crowds who went to see the empty space at the Louvre in fact.

Such losses and disappearances can be involved in the actual act of painting itself. Borrowing from his experience as a house painter, de Kooning would often lay his canvas flat and apply a thin layer of turpentine to the painted surface before sanding it down. The new surface would be smooth and polished, and the repetition of this process would reveal the images of the lost paintings that lay beneath the surface. As he continued to paint, these ghosts would propel him, showing how the creative act is not just based on an emptiness, but can systematically and actively repeat the experience of loss.

But why, we might ask, would anyone want to repeat an experience of loss that is no doubt painful, even tragic in its resonances? A clinical vignette is illuminating here. A man is abandoned by the woman he loves after a long relationship. However he tries to divert his attentions, his everyday life remains saturated with her image and a host of painful memories. Several months later, he is location-hunting for the film he is working on, and his request to use a certain bar is accepted enthusiastically by its manager. During the filming he is, as usual, preoccupied by the broken romance that had marked him so forcefully.

Some months go by, and one day he decides to return to

the bar to thank the manager, a woman who, he now thinks, had been singularly attractive. As he approaches the bar with flowers in hand, one of the waiters passes him in the street and remarks that the gift must be intended for the lady in question. Surprised by the comment, he realizes that, indeed, during the filming, she had shown a number of signs that indicated an interest in him. He delivers the flowers, has a drink, and is too shy to propose a further rendezvous.

A fortnight later, armed with a new courage, he returns to the bar and, not finding the lady present, asks of her whereabouts. When he receives the reply that she had moved to Tobago a week ago, a strange and entirely unpredictable thing happens. Suddenly, there and then, he understands how, although the distressing memory of his first love had been receding, she had none the less been entirely present in every aspect of his life, and that now, this spectral presence was gone.

How can we understand this odd feature of the mourning process? As the mourner put it himself, it was as if 'one lack replaced another'. Yet this second lack was really quite peculiar: he had lost something that he had never possessed. And it was this realization that allowed the mourning process to progress and rendered his life so much less painful. Psycho-analytic writers have often noted how getting over the loss of one object involves the mourning of all the other objects we have lost, which is why it is such a long and distressing process. What the vignette shows so clearly, however, is that ultimately the object we mourn was never possessed in the first place: it was the second encounter with an absence that supplied the truth of the first love story.

Although losing an object can be especially unpleasant if it stirs up the experience of the major losses of our childhood,

the effect, in certain circumstances, can be relief rather than pain when we realize that we never had what we thought we had to start with. We could evoke here the moment in the film *Titanic* when the aged heroine casts the necklace that had been such a significant token in her relationship with her lover back into the sea: repeating the experience of loss has a tempering rather than an aggravating effect on her mourning. It was not an accumulation of objects that allowed her to get over the loss, but the subtraction of an object. Or, in other words, the production of an emptiness. Perhaps this is one of the reasons why the proximity of artistic production to mourning has from time to time been pointed out, not only by shrinks but by artists themselves.

This production of positive emptiness, as we have suggested, is not always at play. In many cases of autism, removing or hiding an object has no effect whatsoever. The child seems oblivious to the concealment or disappearance of objects, and, indeed, often of people as well. If our reality is built up on an exclusion, the creation of a zone of emptiness, as Freud and Lacan argued, this emptiness is not there in autism. It has to be created, not metaphorically, but, as our example showed, quite literally. Maybe this is the difference between why someone would go to look at the empty space where a picture had hung and why someone would steal a picture. It's the difference between literal and metaphorical emptiness.

This suggests that the question of *where we create from* has to be added to the question of *what we create*. When Freud wrote his little book about Leonardo, he thought that the artist created from an unconscious fantasy. Leonardo's childhood memory of a bird inserting its tail into the infant's mouth was, he thought, a cover for a fantasy both of fellatio

and of being suckled. Lacan's emphasis on emptiness and the void seems quite different: we are creating from nothing rather than from something. Freud was interested in what was in the infant's mouth, Lacan in what wasn't. And yet the two thinkers seem to be converging on a similar question. To find out what this question is, we can compare Freud's Leonardo book with Lacan's most sustained discussion of sublimation, his seminar *The Ethics of Psychoanalysis*. It seems bizarre that Lacan makes no reference to the Florentine artist, given his almost obligatory presence in most contemporary psychoanalytic discussions of sublimation, so we could ask: If there's no Leonardo, who do we have instead? Not an Italian man but a Greek woman; not Leonardo, but Antigone.

Why is Lacan so interested in Antigone? His seminar is about ethics, and Lacan wants to explore the nature of the heroine's actions. In the Sophoclean version he uses, Antigone is the betrothed of Haemon, son of Creon of Thebes. Antigone has two brothers, Polynices and Eteocles, and in their bloody struggle over possession of the city of Thebes, they are both killed. Since his act is treasonable, Creon orders that the body of Polynices remain unburied, carrion for vultures and wild animals. Antigone defies Creon's order and buries the body not once but twice, and so is condemned to death by enclosure in a tomb, where she hangs herself. Haemon commits suicide, followed by his mum.

Antigone is someone who renounces the material pleasures of a luxury lifestyle and husband to complete an action, the burial of her brother. She knows what the consequences are, yet remains true to her basic desire. Now, turning back to Freud, what does he see as the real problem for Leonardo? Nothing less than his failure to do what he

ought to have done, his inability to finish his paintings and to follow the path of artistic production. Indeed, Leonardo's dying words, quoted by Freud from Vasari, refer to this very weakness, his failure to work in art 'as he should have done'. Whether Leonardo actually said that is beside the point. What it shows is Freud's interest in the problem of not finishing things, and the centrality of this problem to his theory of art. It is thus quite wrong to see Freud's Leonardo book as a study in artistic creativity: on the contrary, it is a study in artistic inhibition, the failure to create.

We often see this problem in psychoanalytic practice. Someone will start to paint or write, and then stop, or they will come with the initial symptom of not being able to finish a particular work. How can some people sustain a creative activity for a lengthy, perhaps lifelong, period, whereas others suffer from the regular loss of impetus? This is the discrepancy brought out by a critic's baptism of Duchamp as 'Picasso's conscience': every time Picasso created a work of art, Duchamp refrained from creating one. In fact, one could compare Duchamp to the missing *Mona Lisa* itself: unlike so many other artists, he remained a key presence in the art world without publicly producing a work for decades. His absence from the scene continued to have very real effects. Duchamp, we could say, was like a living empty space.

Sometimes it is an identification that gets the creative activity going: an encounter with another artist or source of inspiration gives the initial impetus. We could mention here Picasso's encounters with paintings by Manet or Velázquez, which resulted in a flood of new pictures. But admiration and awe of another artist or work is not enough to sustain the artistic process, and it can just as well block it. Keats had

to stop work on his 'Hyperion' when he realized that his verse was becoming cluttered with the inversions particular to Milton. His idol had become his inhibition.

We find a curious example of such an encounter in the famous collaboration of Picasso and Braque. For a number of years, the two were inseparable, visiting each other's studios with such frequency that a feature in the current painting of one would crop up the next day in the painting of the other. As Braque said, 'It was like being roped together on a mountain.' Neither, apparently, would consider a work finished until he had received the agreement of the other, and several of their works from this time were left unsigned, so it was not immediately clear who had authored them. Oddly enough, the work of these years would become celebrated as the invention of Cubism, equated by many interpreters with the inclusion of more than one viewpoint in the depiction of an object.

In his study of Cubism, William Rubin goes as far as to claim that once Braque had departed for the war in 1914, Picasso, deprived of his friend's viewpoint, became two people: he became both a Cubist and a Neo-Classicist. He had created, Rubin thinks, a 'dialectical other' within the field of his own work. When Braque was there, he could create an image as if seen by two people, but with Braque gone, this duality was internalized by Picasso to create the hybrids of the ensuing years. One might object here that the work of this Cubist period is not really about multiple viewpoints but, as Leo Steinberg argued, about the presence of a discontinuity at all levels of perception. It is amusing, then, to learn that the severely Cubist portraits Picasso turned out during this time required, in utter contrast to his usual habits, prolonged sittings that seemed interminable to his

models. As one scholar put it, perhaps with tongue in cheek, 'Picasso may have wanted the person before him in order to reassure himself that the subject really remained intact while being disassembled on canvas.'

And yet Picasso, despite his occasional fallow periods, demonstrates an extraordinary level of artistic output. Although his life was certainly not without its problems, Leonardo's symptom was not Picasso's. It has always been more of a problem to explain his changes in style than to prove his inactivity: indeed, the so-called fallow periods have frequently turned out to have been quite productive with the discovery of previously uncatalogued works kept by the artist. As Sabartès said of Picasso, he was 'destined to work on and on without respite'. But with Leonardo things are different. It is remarkable how commentaries on Freud's Leonardo book tend to pass over this problem of getting things finished, focusing instead on the fantasy life and family romance of the artist.

Freud made much of Leonardo's childhood memory of a bird settling on his crib and sticking its tail into the toddler's mouth. He assumed the bird was a vulture, and went on to spin his argument around the mythology of vultures which the artist may have been aware of: for example, the fact that vultures were believed by some to be born without a father. Leonardo, for Freud, spent the early years of his childhood alone with his mother Caterina, before being taken in by his father at the age of five. In these years, he would have been preoccupied with the question of where children come from and the role of the father in procreation. Freud also assumes that during this time he would have been the object of his mother's excessive love.

Yet the vulture turned out to be born of nothing other

than a translation error: *nibbio* in fact means 'kite', and this rather spectacular mistake was taken by some critics as the nail in the coffin for Freud's venture into aesthetics. The really hardcore psychoanalysts, on the contrary, thought that the translation error brought out the truth of Leonardo's problem: the kite really should have been a vulture, and the mistake was in fact Leonardo's. What the Florentine artist wrote about his childhood memory was a parody of its rational reconstruction. Big birds do seem to have an affinity with artist's cradles anyway: when James Ensor spoke about his early years, he gave a special place to the memory of a huge sea-bird swooping down through the window and knocking over his cradle. But Freud, despite the translation error, did not believe that Leonardo's memory was an authentic one: on the contrary, he guessed that it had been constructed retroactively after the artist had learned about the symbolism of vultures. Perhaps Ensor's memory had been constructed, then, after reading Freud on Leonardo.

Other biographical facts also raise problems. Later research showed that the young Leonardo was not in fact quite alone with Caterina. Two daughters were born to her, the first when Leonardo was two. Likewise, the details of the comings and goings of Leonardo's father have been the subject of much debate, and Freud's reconstruction is not always plausible. As for the kite, had Freud known that this was the identity of his vulture, he might have been interested in the reference in Leonardo's notebooks to the propensity of this bird to peck the sides of its young and to deprive them of food out of envy. This does not square easily with the image of the tender and loving mother that Freud some-times bestows on Caterina.

Whatever we make of vultures and kites, birds are key

players for both Leonardo and Antigone. In a famous image, Sophocles compares Antigone to an angry bird, screaming in agony when it finds its nest empty. This agony is what makes her give up the mod cons of palace and groom, and persist in her tragic course of action. This fidelity to her desire, this avoidance of any compromise, has made the figure of Antigone incomprehensible to many commentators. Burying her brother Polynices involves sprinkling earth over his body and a recitation. Antigone does this, and pretty soon afterwards she does it again. This is known as the problem of the second burial. Why would she bother repeating her action once it had been technically completed?

The classical scholar W. H. D. Rouse could make so little sense of this that he argued that although Antigone carried out the first burial, the second was in fact the handiwork of her sister Ismene. Another expert thought that the second burial must have been the work of the gods. What these desperate explanations show is the embarrassment we experience when confronted by a phenomenon of pure desire. In the psychoanalytic world, audiences tend to swoon when anyone talks about pure desire, which is why many shrinks are now a bit fed up with talking about Antigone and have turned to Medea instead.

If Antigone persists in her actions, Leonardo offers a very different picture. His difficulties in finishing works in oil or fresco became legendary. In one often quoted story, he stops work on the clay model of a huge horse at the Corte Vecchia, dashes across town to do a bit of work on *The Last Supper*, and then abandons this painting just as swiftly. As one of his contemporaries put it, 'Perhaps Leonardo surpasses all the others, but he does not know how to take his hand from the panel . . .' For Vasari, 'It was because of his

profound knowledge of painting that Leonardo started so many things without finishing them: for he was convinced that his hands, for all their skill, could never perfectly express the subtle and wondrous ideas of his imagination.' This celebrated inability to bring a painting to completion is linked by Freud to an identification with his father. Just as his father had supposedly abandoned him at an early age, so the artist abandons his works.

Freud published this interpretation in the Leonardo book, but in his first, unpublished version, given as a lecture to the Vienna Psychoanalytic Society, he puts forward a different view. As a child, Leonardo was preoccupied with the question of paternity. His investigative urge was sparked by the central problem of why he had no father. But rather than seeing Leonardo's inability to finish things as an identification with his father, Freud argues that it is in fact the mark of his failure to complete his initial, and primary, investigation. Since he found no answer to the question about paternity, his art would remain incomplete. This hypothesis is very different from the published explanation of Leonardo's trait: it is not an identification with a signifier of his father – 'to abandon' – but, on the contrary, the absence of a signifier – the failure to find an answer to his question about why his father wasn't there. Leonardo worked not from the point of an identification, but from the point of an absence.

In the published version, Freud claimed that the identification with his father was an impediment to his work as an artist, since it blocked him from finishing. But, at the same time, it was his rebellion against his father that allowed him to work as a scientist. A strange tension appears at this point in Freud's argument. Leonardo's turn to scientific studies is interpreted as a rejection of art, and therefore of a certain

kind of sublimation, understood here in the sense of a creative activity that has its roots in childhood difficulties and which produces socially recognized products. Yet Freud gives scientific activity a medal of honour in the league table of sublimations, since he equates it with a rejection of the authority of the father: received knowledge, the wisdom of our fathers, is put in question, thus allowing the creation of something new. Would the purest form of sublimation then involve scientific as opposed to artistic activity for Freud?

Although there are good reasons to treat with suspicion some of the canonical separations of science and art, enough distinguishes them to make the question interesting. And if much of science aims at making its products cheap enough to invade every home in civilization, art aims at exactly the opposite. Cheap art for all is an idea with the best intentions, but is at odds with the principle of giving up everything for nothing. Science, on the contrary, tells us how little we have to sacrifice to access its products: in many of the Western countries, you can get a hundred TV channels for practically nothing.

The relation of sublimation to science is touched on in a very difficult passage we find in one of Lacan's writings. After evoking the shift from a vision of the world based on symbolism to one based on mathematical abstraction, Lacan writes, 'The cabbalistic notion of a God who would have knowingly withdrawn himself from matter in order to leave it to its motion could have favoured the confidence given to natural experiment as something that could rediscover the traces of a logical creation. For this is the usual detour of all sublimation, and one could say that outside physics this detour remains unfinished.' This almost impossible passage

is chock-full of unexplained concepts – the cabbalistic God, logical creation, natural experiment – and a couple we have already met – sublimation and the unfinished. So what is Lacan saying here?

The cabbalistic reference evokes first of all the theory of the world's creation. When Barnett Newman said that 'the artist must create from emptiness, from chaos', his juxtaposition of these two terms would, in most theological arenas, have constituted a heresy. In these debates, chaos was radically opposed to emptiness: one had to choose. Either God created the world from a primal chaos, in which case something would have had to exist before the world, or He did it out of nothing, from emptiness. The creationist idea of a world born *ex nihilo* is thus the exact opposite of the theory of a world born out of chaos.

The *ex nihilo* doctrine has often been attributed to the cabbala, but in fact scholars have shown that this was a theory of late Rabbinism and rejected by the cabbala as such. Although it seems likely that Lacan had the former idea in mind, the cabbalistic notion substituted for the *ex nihilo* theory is in fact even more suggestive: according to the strange doctrine of *Tsimtsum*, the world owes its creation to God shrinking. How could God have created the world if He were everywhere already? One cabbalistic response is to assume that He did so by abandoning a region of Himself. In contrast to the classical theories of emanation, in which the world is created by an emanation from God, this is a contraction theory, with an incredible shrinking God. God went into exile from Himself, and it is probably no accident that this theory emerges from Jewish tradition. We often hear it quipped that the problem is not getting the Jews out of exile, but getting the exile out of the Jews, a task made

even more difficult by this divine precedent of voluntary exile, which created the very world we inhabit.

The reference also evokes the seventeenth-century debates on the role of God's will in material motion. Had God created a universe like a finely tuned clock and left it to run for itself or, as Newton believed, was He continually active in its operations? Newton, and many others, gave space all the properties that had traditionally been attributed to God – like omnipresence and infinitude – but when people no longer saw the necessity of including Him, space still kept all His properties. God, as it were, went undercover. What remained constant was the mathematical machinery of Newtonian science, and this is perhaps the logical creation that Lacan refers to. Natural experiment discovers the laws of nature established in the logical creation. Now, why is sublimation a detour here?

Lacan had begun by contrasting a world view based on symbolism to one based on mathematical abstraction. A world view based on symbolism is one in which the stars and the motions of the planets are supposed to represent the antics and decisions of the gods, formed in the image of ourselves and our bodies. When he says that outside physics the detour of sublimation remains unfinished, he is assuming that physics is a fully formalized, mathematical science that has distanced itself from occult symbolism, in which aspects of the world would be identified, for example, with parts of the human body. The formulae of algebra replace the symbolic equations between the world around us and our body, found, most famously, in theories of the microcosm and the macrocosm. To get there, however, there is a passage through this process of equating the universe and the body. Sublimation, on this model, remains unfinished until it

has reached the level of formal, mathematical abstraction.

If we now return to Freud's discussion of art and science with Leonardo, we see the apparent tension in his argument resolved. If science as sublimation involves a process of formalization, this is exactly where Leonardo doesn't follow the detour to its conclusion. As is well known, Leonardo's science avoids the mathematical bias that would characterize so much of the later work of the so-called scientific revolution. One scholar went so far as to call this inadequacy in mathematics 'the tragedy of Leonardo'. Although it is unfair to admonish him for this apparent failure, as it is to impose later concepts of both 'science' and 'art' on his endeavours, it does show the logic of the psychoanalytic argument. Leonardo's movement from a certain kind of artistic practice to science remained faithful to a vision in which the body, as opposed to mathematics, cast its shadow over everything. Even in a simple stone wall, he would say, 'you will be able to see diverse combats and figures in quick movements, strange expressions of faces, outlandish costumes, and an infinite number of things'. The human figure is everywhere. And especially, for Leonardo, the penis. His interest in erection and detumescence seems to frame so many of his projects, including his famous efforts to construct vehicles for flight.

Lacan's amazingly difficult sentence suggests that mathematical abstraction is at the end of the detour that goes through the image of the body. When research in physical science reaches the stage of formalization, the world is empty rather than full of the body. Leonardo's difficulties in science, according to this argument, were due to the failure of passing beyond the body to the level of abstraction. True sublimation, then, would occur not in art but in science and,

more precisely, in the special kind of science that we have known since the seventeenth century.

The concept of sublimation seems to have become hopelessly complex. After questioning the intuitive idea that it consists in the diversion of an instinctual sexual energy to supposedly non-sexual artistic goals, we then defined it as the elevation of an object to the dignity of the Thing, where the object in question – be it a new style in poetry or a work of visual art – acts as a kind of screen beyond which is an inaccessible zone that we keep our distance from. And now we have the idea that sublimation is about the investigation of nature distanced from the spectre of the image of the human body. Can these apparently disparate perspectives be reconciled?

The most obvious link is the idea of a movement away from the body. Rather than obtaining satisfaction from parts of the body, like the drives described by Freud, sublimation involves the creation of new objects or activities that are situated in the same space that the drives revolve around, the emptiness that bodily satisfaction attempts to fill. Rather than the eternal return to the body, there is a production of representations or screens, which evoke this empty space, aided by the social recognition of art, which accords a special place to creative practice. Science is sublimation to the extent that it supposedly distances itself from the image of the body, but its relation to the Thing is quite different from that of art. Rather than evoking it, science doesn't want to know anything about it. Which is why, perhaps, the Thing will habitually return through science in its most terrifying, catastrophic forms: the nuclear bomb, biological warfare, certain consequences of genetic engineering, and so on.

We have moved away from the classical psychoanalytic

presupposition that artists are the people who sublimate, but in a particular sense: the artist is someone who doesn't *complete* the arc of sublimation. Without the setting up of correspondences between the world of natural objects and the body, could Picasso have seen a cigar in the broken stick at Royan, or Sarah Lucas the arrangement of sexual characteristics in her constructions of fruit, vegetables and cigarettes? These would reach the level of sublimation proper only if someone bothered to reduce them to mathematical equations. There are certainly good reasons for separating the practice of art from the idea of sublimation, but isn't there still a link between the most abstract – here, the mathematical – and the body? And if we move the argument from science into art itself, does this mean that the most abstract art is somehow further removed from the body than the art that we call representational?

When Mondrian painted his famous polychrome grids, it seemed as if the abstraction of line had really triumphed over the dubious plentitude of representational art. Here, for some, was pure form. But, as one of Mondrian's friends noticed, this pure form was in fact still full of the body: as his grids became more and more spartan, the painter was increasingly preoccupied with his eating habits, eventually adopting the Hay Diet which consists in the rigid compartmentalization of whatever it was to be eaten. As his grids separated space, so his diet separated one food from another. He had adopted, we could say, an entirely abstract diet.

Ernst Gombrich once wrote that 'since artists cannot paint without eating, it is certainly possible to base a credible system of art history on the needs of the stomach'. When Appeles and Protogenes drew their indescribably fine lines, it may have been an invitation to the classical scholar to

start investigating their diets. Although the links between abstract art and what artists are eating could turn out to be a new chapter in art history, we should pause here to consider the validity of the idea of abstraction itself.

According to a popular misconception, abstraction is opposed to representation. Old art is representative, new art (or some of it) is abstract. But in the days of Appeles and Protogenes, for example, much art was concerned with reproducing ideal types, forms that could never be found in nature. A human body could be judged in relation to an ideal body, but an ideal body could never be found in a human. That's why, for Seneca, the boy in Zeuxis' picture must have been superior to the grapes: it was more idealized, and hence, for the birds, less real. Art was not about representing reality, but representing ideas, which are by definition abstract.

Likewise, how a body or landscape was judged in later art would depend on how previous artists had represented it. It could be more real or less real depending on how it had been painted or sculpted before. As Gombrich showed so convincingly, artists need an idiom, a vocabulary, before they can start to 'copy' anything. And this vocabulary comes from other art. These points are fairly obvious, but the myth of abstraction is more tenacious and the concept is often taken for granted even when terms such as 'realism' are being put in question.

An abstract picture is sometimes supposed to be one that doesn't represent anything immediately recognizable. But as the painter Jean Bazaine stressed, abstract is not the same as non-representational. In one sense, to abstract is simply to exclude from a work of art any elements that are not compatible with the embodiment in matter of the form

conceived by the artist. Since all art involves such an exclusion, art has never been anything but abstract. Even while it was representing, as Bazaine argued, it was doing something else than to represent.

This notion of exclusion is in fact contained in one of the original senses of the term 'abstraction'. With the *Mona Lisa* gone, we noted how one French newspaper could describe the shocking disappearance, in its headline, only as 'Unimaginable'. But in London the correspondent of *The Times* chose his words more carefully: 'What is perhaps the most famous picture in the Louvre', he wrote, had been 'selected for abstraction.' Abstraction here means theft or removal. Leonardo's masterpiece, the paragon of true to life art, had been made abstract by a thief. True to Bazaine's formula, the act of abstraction involved the exclusion of all the other paintings that were incompatible with the vision of the person *The Times* called 'the abstractor'.

Another way of looking at the problem of abstraction is through the notion of line. A line is a way of separating space, and to abstract may be equated with even the simplest division of space. The use of lines thus involves an abstraction, defined now as the act of separating. The most representative, realist portrait is an abstract one in this sense. Since linear expression separates space, the more that formal elements are stressed, space itself might come to seem unfamiliar, discontinuous, to generate the apparent 'unrealistic-ness' of much modern art. Etienne Gilson argued that, in this sense, abstract art is a development of design in general.

Children's drawings show a special preoccupation with this question of the separation of space, and psychologists have wondered why it is that a street, for example, is so often rendered by two parallel lines rather than two converging

ones. The child, after all, must 'see' two converging lines like the rest of us. When Max Ernst was a boy, he ran away from home to follow his local railway tracks to find the point where the rails and the telegraph poles would meet. So how can this apparent disparity be explained? One answer to this question is that children draw not what they 'see' but what they 'know', that is, the idea or concept of a street. Objects are made to be *recognizable* as concepts, and that is why this kind of artistic production is at once so easy to decipher and so difficult to comprehend.

This dominion of the world of language and signs is seen also in the function of images in what ought to be the closest people get to the reality of the body: in medicine. A study at Harvard showed that realistic images of organs added little to students' understanding of a medical lecture, but cartoon drawings of the same organs contributed significantly. Recognition depended on identifying the *concepts*. And in one profession outside the art world where looking is the main part of the job – passport inspection – it was found that caricatures were more effective for recognizing the human face than high-calibre passport photos.

Taking these details seriously implies that the world of represented reality is structured by language: the concepts that the child is attempting to embody, the idea of organs and the reduction of the human figure to a few, exaggerated lines that follow a convention. It is less sight than ideas that matter. And ideas, so it would seem, have an affinity with lines. Not because it is with lines that letters, and hence words, are constructed, but since lines, as we saw with the example of cave painting, embody signifying systems that intrude into the world of visual form.

Doesn't this give us a clue to reinterpret the enigma of the

background landscape of the *Mona Lisa*? In his study of Asian and American art, Claude Lévi-Strauss was struck by the ubiquity of split representation, the practice of taking portions of the human face or body and combining them to reconstitute new figures. Two profile views of the same figure, for example, could be combined to give a 'frontal' view. The subject is quite literally dislocated into parts, and then combined according to conventional rules that have little to do with 'natural' perception. The resultant image may then give an indication of social rank, prestige or spiritual meaning.

Now, this formal process of dislocation and combination serves, Lévi-Strauss argues, to express the splitting between what he calls 'the dumb biological individual' and the social person he or she must embody: the design confers on a person their social existence, their place in a structure. In other words, it is the formal side of the technique of split representation that evokes the presence of language, in the sense of a system of representations imposed on the subject.

If we consider the rocky background of the *Mona Lisa*, don't we find something similar? Beyond the question of the symbolism or conventionality of the landscape, doesn't its lack of symmetry evoke the split representation that Lévi-Strauss made so much of? It is as if a landscape had been segmented and then the two parts recombined, a practice that in fact was sometimes used for the filling in of contemporary backgrounds. What matters is the ever so slight failure of the two parts to cohere, thus drawing attention to the formal process itself: the action of a symbolic system to organize visual reality. There are no words in Leonardo's picture, but the background involves a reference to language.

This does not mean that art *is* language. And it doesn't mean that art is about saying things. All it means is that our

immersion in the visual world is guided by language, and that language frames much of our experience of visual recognition. And, as we have argued, that many forms of art are concerned with the effects of language on our reality. Despite this, the presence of concepts in our relation to a work of art doesn't mean that the work is communicating, or even that the artist is trying to communicate with us. As Van Gogh put it, 'The painter says nothing', and as Bacon echoed, 'I'm not saying anything.' Art, after all, is about making, not communicating.

The imperialism of concepts and language over the visual takes us back to the problem of creation and, in particular, to the question of Antigone's actions. What sense would it make to talk about a creative act here? If we remember Klee's remark that true creation is the creation of a positive emptiness, would this mean an emptiness in the space of concepts and language? Is the artist someone who creates a clearing, an empty space, in the world of signs and ideas so that something new can emerge? Would this return us to the original alchemical sense of the term 'sublimation'?

Antigone is someone who, in the Sophoclean version, persists in her actions. She is like the Terminator who keeps on trying to fulfil his mission despite losing more and more body parts. The end to the action is paramount. For Antigone, the mission is to bury her brother. Now, who is this brother? He is a man who has been designated an outlaw, and who has become the bearer of all the insults and chastisements that the City knows. There is thus a human body and a whole lot of things that are being said about this

body. And here we have the key point. In her act, Antigone aims at the point beyond the set of things that are being said about her brother. She is aiming at a point not beyond language, but rather at the junction, the edge between language and being.

In her insistence on burial rights, this edge becomes the key factor: it represents, after all, the line of demarcation between human and animal or, more precisely, the minimal sign that a human body is caught up in a social network, a symbolic system, indexed by the fact of burial. She refuses to identify Polynices with all the nasty things being said about him and at the same time she refuses to see him as just a dead, animal body. Her act, according to Lacan, aims at the point of splitting between language and being. He calls this the point of *ex nihilo*.

If we link Antigone's act to our discussion of sublimation, does this mean that we should be talking about creative acts rather than about artists and works of art? This might mean a lot of problems for the art world. When the twentieth-century notion of 'the artistic act' began to capsize the more traditional idea of 'the artist', one critic pointed out that since anyone could in principle be the author of creative acts, gallerists and art dealers would no longer simply be able to visit studios and lofts looking for new blood: they would have to carry out house-to-house searches.

Despite such impracticalities, there is still a great deal to be said for the idea of the creative act, and it opens up the whole question of sublimation. Antigone's act leads her in the direction of death. Her desire is apparently pure, unhampered by emotions of self-preservation and the attractions of material comfort. Now, Freud tells us that the aim of a drive is satisfaction. Sublimation involves the satisfaction of a

drive, and yet, he says, it involves a change of aim. There seems to be a contradiction here. But if we use Antigone as an example, sublimation becomes the process of desiring as such, or, more precisely, the action of changing an object: the satisfaction would be in the change itself. The idea here is that sublimation is 'change as such' as opposed to fixation to an object, an idea that reminds us of Picasso's definition of a picture as 'a sum of destructions'.

The purer the desire, the more is given up, as we see in the case of Antigone and, indeed, in that of so many of the martyrs of the Church. She may have been fixated on her brother, but she has given up all the other elements that represent conventional objects of desire. More significantly, she has privileged the formal dimension of language, represented by the demand that a human body has burial rights, over the content of his particular life. This is perhaps what Freud was getting at when, in his last discussion of sublimation in *Moses and Monotheism*, he linked it to the recognition of the abstract dimension of paternity over the physicality of the relation to the mother. Form triumphs over content, the signifier over the signified. And yet this triumph, as Antigone shows us, involves the eclipse of human life: it is now the shadow of death that starts to take centre stage.

In civilization, after all, pure desire is an alien species. When someone manifests it, perhaps through acts of sacrifice for a cause, we can make no sense of it: giving up the common denominator of self-preservation and material comforts goes against what our Western society has privileged. With pure desire comes a rejection of the feelings of those around us: Antigone is not acting for the good of others but, it seems, for her own desire, even if things become more complicated if we question the link between this desire and

that of her mother. The apparent purity of desire is a terrifying notion, and civilization calls those who adhere to it criminals – or artists. An artist is like a state-sanctioned criminal, someone who shows the particularity of their own desire through the 'sum of destructions' that can make something new emerge.

This might seem a very romantic notion, and it depends to a great extent on what image of the artist a society constructs. Although the idea that the artist must make new things is a relatively recent one, the innovations that have always taken place even in times when copying and tradition were programmatic show that change has a special value. Indeed, there is often a fine line between the older idea of the artist as someone who does it *better* and the more modern idea of someone who does it *differently*. In this latter conception, rather than receiving the form of what they want from others, the artist shows that their own desire is peculiar, dissociated from the objects that society values and linked to objects that are always fundamentally *different*. And yet at the same time, society recognizes and sanctions this difference by giving a value to works of art.

The priority given to desire can generate its own problems. Artists might be elected to display a 'pure desire', but it is never, thankfully, that pure in practice. It can remain caught up with all the things that Antigone rejects: hence the often unpalatable nature of the remarks reported of successful artists to the effect that pragmatic or financial matters have a certain importance to them. The fact that artists share such concerns with the rest of us is not the relevant factor here. What is significant, on the contrary, is the surprise or indignation often displayed by the media when it turns out that an artist is no different from anyone else. In their

modern straitjacket, artists are often supposed to embody nothing less than the purity of desire that, for someone like Antigone, had such lethal consequences.

This particularity of desire is the reason why we don't like fakes. The most brilliantly executed art forgeries might fascinate us with their skill, but they can't satisfy us in the same way as what we take to be the 'original'. Visually, we might not be able to tell the difference between them, yet we still feel disappointed, cheated. It is thus not what a picture *looks like* that matters so much as the singular nature of the desire that is embodied in it, its individual signature. The idea of forging a desire makes no sense, and it contradicts this basic function of art in its social context. It's where the work comes from that counts.

To demonstrate the difference between the particularity of desire and the uniformities that are imposed on us means that art is all about finding new resonances, new styles, new products: what matters is the 'change of object' as such. In André Breton's words, to 'form things in opposition to the things of the external world'. The only problem with all this is that the more one follows one's desire, as Antigone shows, the more terrible is the price to be paid.

In his later work, Freud saw human life as a dynamic of the fusion of Eros and the death drive. Speaking of sublimation, he said that the erotic component no longer has the power to bind 'the whole of the destructiveness that was combined with it'. The death drive will then find it easier to gain control over the libido. The more we sublimate libido, the more the ego runs the risk of itself becoming the object of the death drive.

This means that sublimating involves a massive risk. It is significant here that Freud preferred the term *Sublimierung*

('sublimating'), as opposed to the more obvious *Sublimation* ('sublimation'). *Sublimierung* implies a process rather than a product, and so, it would seem, it remains unfinished: to complete it would make it the equivalent of the death drive. We are back with the idea of sublimation as an arc or circuit that artists fail to complete. When Freud chose to quote Frederick the Great's saying, 'Every man must find out for himself in what particular fashion he can be saved', at the end of his book *Civilization and its Discontents*, we can understand it as suggesting that it is not by sublimation that we will be saved, but by sublimating. It is an incomplete, impure activity that, for Freud, gives us a chance.

This impurity can be found in the work of a painter whose nature scenes hardly seem to evoke the Freudian battle of Eros and the death drive. As part of his teaching at the Art Institute of Chicago, James Elkins taught a class that involved copying paintings, yet when a Monet was first chosen by one of his students, things turned out to be far more difficult than expected. After months of work, the student was still unable to get the desired effect, producing instead what looked like a computer-screen image of the painting in question. As Elkins and the student tried to understand the impasse, it became clear that the key to the Monet picture lay in the exact gestures that had made the individual brushstrokes. As they then tried to emulate the French painter's hand, they made a surprising discovery.

Given paints with the right texture, it was possible to approximate the Monet brushstrokes, but only when a bizarre rhythm of gestures had been established. Small gobs of paint would rest on top of the brush while the dry brush-end was pushed over the canvas. Suddenly, the brush would be turned so that the wet paint would be plunged into the

weave, planting a thick blob of paint as part of the same mark. The brush would then be lifted again, allowing the body of the mark to trail off as the paint broke off from the hairs of the brush. As Elkins points out, Monet worked here with great violence, followed almost instantly by sudden gentleness: his body was working, as it were, against itself. Monet's body 'never quite does', Elkins says, 'what it wants to do'. This separates Monet's technique from the unidirectional brushwork of so many other painters, who, for that very reason, prove easier to copy.

Perhaps we find an answer here to the mystery of the painter's astonishing popularity and the success of the Royal Academy show we mentioned earlier. Although the surface of Monet's pictures presents us so often with the calm of a garden scene, the paintwork itself is the product of a terrifying visceral contradiction, the twisting of the body in two contrary directions almost at once. Beyond the pleasing nature of the painted vista is the convulsive struggle with which Freud characterized the entwining of Eros and the death drive. And doesn't this allow us to understand the strange and isolated remark Bacon once made about the French painter: that he wished to paint the human mouth as Monet had painted his sunsets.

Freud's sublimation theory is about an ongoing activity rather than a finished product, and it implies that there are many artists busy not finishing works of art. It is significant here to remember that Freud's real interest in the study of Leonardo was in exactly this question of completion, of finishing things. Whether Leonardo's works were actually finished or not is less important for Freud than the artist's feeling that he had left something unfinished. Even the *Mona Lisa*, which is generally seen as something complete, does

not escape from this spectre of incompletion. Vasari says that Leonardo 'worked on the painting for four years, and then left it still unfinished'. Although it is clear that Vasari had not seen the picture, his verdict would become correct in the sense that at some point in its history it was cropped, pruning a few inches from either side of the panel to remove the columns we know of from early copies.

This problem of completion can tell us something not only about sublimation as a process, but about the nature of the work of art itself. Take, for example, one of the most celebrated unfinished works of modern art, Marcel Duchamp's *The Large Glass*. The artist worked on and off on this project for at least eight years, and it suffered more than one accident that he then incorporated into the work. As Joyce said of his own writing, it would keep academics busy for centuries, and *The Large Glass* is well on track for doing just that. There are any number of interpretations of this complex work, and Duchamp was careful never to explain it or, for that matter, even to suggest that it could be explained. It preoccupied him in a strange way: he would work on it a little bit, then leave it for months, add a bit more, then turn his attention to other matters. And yet, as he said, when it went on display many years before his death, it was 'definitively unfinished'.

Duchamp's customs and habits are notoriously puzzling. He played a lot of chess, didn't really produce too much art, and yet had an enormous influence. Scholars have combed his biography and his work for clues to his psychology, without turning up a great deal. Despite the cynicism of his most recent biographer, such efforts are by no means doomed to failure: in fact, there is enough there to keep the psychoanalyst happy. But rather than trying to link the 'biography'

and the 'work' and produce a psychobiographical reading, there is another angle that is more interesting for us here. As we sift through the various interviews and anecdotes, the one thing that emerges unequivocally is his elusiveness, his unwillingness to be pinned down by a signifier.

Whatever people said about him, he slipped out of. In the same way that he continually slid out of the uniforms that the art world tried to give him: the Cubist, the Dadaist, the Surrealist, etc. His mockery of theories about his own work or about modern art in general can be understood as a valid reaction to the pretensions of the time, but represents, more fundamentally, a rejection of the signifier as such. The great mystery of Duchamp is something he created himself by this refusal. And it seemed to work: despite the apparent rigidity of his way of life, no one knew what he was about.

Duchamp's refusal to be pinned down is reflected in his question, 'Can one make works which are not works of art?' If a work of art becomes a signifier the moment it is looked at, thought about, written about, bought and sold, the project of creating works that are not works of art becomes part of the more general project to refuse the dimension of the signifier as that which represents you. A work of art becomes expressive of the artist in any way that people choose to interpret it. In the act of interpreting, and even in the act of attributing a work to an artist, it becomes a signifier representing him or her. The rejection of this dimension is a rejection of a dimension of language, and this unwillingness to be committed is echoed in his relation to his work: the first readymades were signed not 'by Marcel Duchamp' but 'from Marcel Duchamp', a distancing we find again in his lack of any emotional reaction to the news that the glass panels of *The Large Glass* had been shattered during transportation.

One might care to add to these examples Duchamp's obsession with chess, a game that is in some sense about the effort not to be pinned down. If chess, as Duchamp said, was a system, playing involved not losing to that system. Although there are many facts that link Duchamp's passion to his family history, there is also this more formal quality of outmanœuvring and escaping capture in a game. This can tell us something, perhaps, about artistic production. Although Duchamp's example is in a way extreme, it shows the effort of the artist to make something that doesn't represent him or her. If the characteristic of a signifier is to represent a subject, it does so for other signifiers: it links the representation to a chain of other representations. That's how an artwork enters the world of human reality: people talk about it, make it mean things, give it value, etc. In that precise sense, it is like speech: we say things that represent us, but our words mean more, or less, than we want them to. And what they mean is determined by how others hear them.

Although some strands in the history of art privilege the work of art as a message, Duchamp's effort sheds light on this other dimension of our relation to language. The act of making a work that isn't a work of art is the act of making a work that isn't a signifier: the problem is, once it's made, it immediately *becomes* a signifier because people talk about it and it enters the art world and the world of signs. This suggests two things: that the work breaks with conventional modes of representation (as the readymades did), and that, once it's done, since that means it becomes a signifier, something else has to be created. As Lucian Freud put it, 'The process of creation becomes necessary to the painter perhaps more than is the picture.' The work of art, in this sense, is necessarily unfinished. The game of chess is always lost, and

so a new one is begun. In Bacon's words: 'I do not believe paintings are ever finished.'

The standard interpretation of Duchamp's failure to complete *The Large Glass* relies on the Romantic view according to which the viewer is less a consumer than a producer. The vogue of deliberately unfinished works of art incarnated the aesthetics of the *non finito*: it was the viewer's job to complete the picture with their own act of the creative imagination. Confronting the enigma of *The Large Glass*, it is therefore up to the viewer to do some work, bringing their own creative capacities to bear on it. Although such an interpretation is by no means invalid, it misses the point we have tried to emphasize. The work is not unfinished in order to encourage the creative act of the viewer: it is unfinished *because* of the creative act of the viewer. Viewing it as a work of art makes it a signifier, and hence it has failed to represent the subject *not* as a signifier. From this perspective, simply to designate a work as a work of art makes it unfinished.

Perhaps these ideas can allow us to approach another strand in the history of art, one that concerns paintings which seem not unfinished but, on the contrary, too finished. We have already discussed the story of the painted grapes that were so lifelike they deceived a flock of birds, and the notorious painted spiders and flies that grace many Dutch and German works from the fifteenth century onwards tend to be situated within the same tradition. Numerous anecdotes recount a viewer's efforts to brush the insect from the surface of a painting, demonstrating the painter's skill and unique ability to depict nature as it really is. The presence of painted

insects is generally interpreted as a sign of virtuosity, bringing out the naturalistic qualities of artistic achievement.

But isn't there another function to these strange intrusions into pictorial space? A painted insect can certainly impress us with its lifelike qualities, and hence act as a kind of signature of the artist. And yet there is also something ineffable, meaningless and contingent about it. We could interpret this redundant, meaningless dimension as incarnating that strand of artistic production which is all about representing the subject not as a signifier, just as we saw with Duchamp. This seems to generate a tension with the idea of the insect as a sign of virtuosity, a signature, but can't we in fact equate a signature with exactly that part of our being which is fixed, not subject to the shifting networks of language? Incarnated in the brute image of the insect, it evokes that aspect of ourselves which consists in being merely an object that is looked at, void of subjectivity. Artworks, in this sense, are us.

Taking the above argument seriously implies that works of art may be inhabited by the effort not to be works of art. As Eva Hesse put it, 'I would like the work to be a non-work.' However finished they may appear, they contain a contradiction that hinges on the desire to be incomplete. As representations, they alienate the artist, and as pure objects, they might try to escape being representations. And this is a dimension of human life as such: we are caught up in networks of meanings, concepts and representations, yet at the same time we are brute, meaningless bodies. This is in fact exactly the splitting that visitors to the clean, sanitized space of the modern gallery often complain of: as they enter, they are suddenly aware of their own shabbiness, as if their very presence were an intrusion into the white space designed,

after all, to welcome them. Their position is that of the painted spider or fly, but the problem is that to represent or incarnate this dimension of the brute, ineffable body, we are back once again in the networks of representations, concepts and meanings.

This tension between works and non-works is reflected in a feature of much contemporary writing about art. In a classic article, Brian Ashbee mocks the art-criticism-by-numbers approach rampant in much of today's popular and academic press. After listing the almost obligatory rhetorical devices of the critic worth their postmodern salt, he describes the 'ultimate test', to 'concoct an argument that can be applied, with apparent relevance but total unintelligibility, to any work whatsoever'. If you can substitute the names of three very different artists and your sentence still seems to make sense, then you have passed the test.

Take a sentence such as 'X's paintings operate in the space between a subject and a non-subject.' Now substitute for 'X's paintings' either 'Bacon's figures', 'Judd's boxes' or 'Gillian Wearing's people'. Amazingly, as Ashbee notes, it works. The key is the pair of opposed concepts, which 'act like gateposts through which any precise meaning can make good its escape'. Even more troubling is the fact that it all still works if you introduce a negative into the sentence: 'X's paintings refuse to situate themselves in the space between a subject and a non-subject.' And you can go on to substitute a whole range of other opposites into the place of subject and non-subject: nature and culture, presence and absence, emptiness and plentitude, and so on.

Now, all this is very worrying, and it certainly serves as valid criticism of what Ashbee daintily terms 'art bollocks'. But there are two problems here. First of all, replacing 'X's

paintings' with the names of different artists and their works generates sentences with very different meanings if we have seen the works. And secondly, although Ashbee is shocked by the levity of art bollocks, doesn't the true horror here lie in the possibility that its authors are in fact hitting the nail on the head? The apparently casual and indiscriminate use of opposed concepts might well be tightened up, but doesn't it testify to a general feature of so much artistic production, which is exactly to be two different things at once? Any pair of opposites can be used, as long as their opposition remains, and the artwork avoids reduction to the one or to the other. The opposition of concepts is an empty, formal feature of language, and artworks, as we have seen, can never avoid being turned into language, and hence may strive for an existence as 'non-works' – one of the effects of which is to generate contradictions in the field of concepts. The gateposts might not matter, but the in-betweenness does.

The artistic image itself, as we have seen, has a special relation to the idea of incompleteness: as a work of art, it is necessarily unfinished. But visual images can be incomplete in other ways. In his early work, Freud argued that as we search for the memories of our childhood, we can often come up with only a handful of trivial images. He thought that these memories acted like screens: they blocked out any access to the painful events of our childhood and at the same time pointed to what lay beyond them. These memories were like markers, covering and at the same time pointing to experiences that were perhaps impossible to represent or give an image to.

The image did not tell the truth because the truth was beyond the register of imagination or representation anyway. In psychoanalytic practice, we often find that patients who have undergone some form of traumatic experience describe again and again a trivial aspect of the scene – a detail of furniture or fabric – although the 'picture' as a whole remains inaccessible. The little visual detail stands in for what can't be visualized. This is indeed the basic principle of our everyday relation to the photographic image. One of the commonest forms of photography is the family scene, the gathering together of relatives for the communal meal or celebration. Everyone smiles, but we all know very well that such occasions usually involve pain and suffering. The pain is masked by the smiling image, as if the factor of a screen were built into the function of the photographic image itself.

Images, once again, matter due to what they evoke as a 'beyond'. They have a screening function, and even the one image that is chosen so often to incarnate the ideal of beauty, the *Venus* of Botticelli, covers over a gruesome history. This Venus that rises from the waves is so dazzling that one is tempted to forget where she came from: after Saturn castrates Uranus, his mutilated genitals are thrown into the sea, and from this horrific act the goddess of beauty is born.

It is curious, in fact, to note the strange convergence of images of beauty and of horror. When contemporary artists make headlines by building their artworks around some obscene and horrific crime, they are following a hallowed tradition. Lacan was especially interested in Sophocles' evocation of beauty at the point in *Antigone* at which the heroine has fully demonstrated her readiness for death. Although Lacan's reading of the Greek has been recently contested, his comments on the screening function of beauty

are still pertinent. Sophocles uses the word *kalos,* which occurs rarely to describe a woman in Greek tragedy, and one could also cite its use in Euripides' version of *Hecuba* at the moment preceding Polyxena's death before the army assembled at Troy. The screen of beauty is the final barrier before the reality of death. Irenaeus evoked the same lethal beauty in his description of the burning of Polycarp, the Bishop of Smyrna: an uncanny beauty superimposed itself on the horrific image of the martyr's burning flesh, just as Soutine would find a serenity in the image of rotting, decomposing matter. Beauty functions here as a limit, a marker of something beyond itself.

Lacan also drew attention to the beauty of the heroines in the work of the Marquis de Sade. Subject to the most unbearable assaults and violence, they remain alive, and still in possession of their pristine beauty. Sade's strange insistence on this feature suggests, Lacan thought, that beauty functions as a barrier beyond which is the zone of the Thing, the void that can be imagined in one way as death or destruction. Lacan's interpretation of Sade is echoed in the historical events contemporary with the sad noble's literary career: as the new Republic opened the Louvre in 1793, displaying its art treasures to the outside world, its concentrated public-relations effort aimed at dispelling the memory of the horrific events that had made it all possible. Beyond the beautiful screen of painting was the guillotine.

The history of Western art has put another figure here, at the junction of life and death, framed in an image that aims to cancel out all other images: the crucified Christ. When Bacon said that he tried to paint 'the one picture which will annihilate all the other ones', we can remember the importance of the crucifixion triptych at the start of his distinctive

work in oils. The crucifixion is not simply the image of a dying man, but, as much religious writing on the representation of the Passion shows, the image *of what an image is* in the first place: a screen that separates us from the void and at the same time evokes it for us.

This screening function of the visual image is addressed in an unsettling way in the recent work of the sculptor Marc Quinn. A series of polished marble statues depicts limbless figures in classical poses, evoking the familiar sight of antique sculpture. Yet Quinn's models are not complete to start with: on the contrary, they have suffered real illness or accident. If the *Mona Lisa* is no longer a painting but the symbol of painting in popular culture, what is it that symbolizes sculpture in a similar way? The armless figure of Venus might be the best example, symbolizing both sculptural production and art itself, an

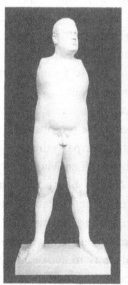

emblem of what is 'civilized' and distinctly human. Yet this privileged image harbours a tension: an armless, fractured, incomplete figure is symbolizing classical sculpture, with its emphasis on completeness, symmetry and ideal form.

The symbol of the arts, of the dividing line between nature and culture, is not the whole human figure here, but the partial one. What Quinn does with his marble figures is to make us reassess the function of the partial figure, inviting us to see classical sculpture in a new light. Partial figures were used for centuries to train artists to render the complete, non-partial figure, and when we see an incomplete figure, this association is so powerful that we are often unable to see it as incomplete. Albert Elsen could say that the partial figure today 'is so frequently seen and taken for granted as to be often invisible to the artists themselves'. Even in a work as prestigious as the Florentine *Pietà* of Michelangelo, in which the figure of Christ has suffered a strange amputation of the leg, our way of looking at sculpture is so saturated with the assumption that partial means complete that it took a few hundred years for the missing limb really to be missed, when, true to form, the critic Leo Steinberg started asking questions about it.

Why is it so difficult to see a partial figure as incomplete? One reason must be that we read these sculptures as symbols of the classical age and, as such, their partialness is subordinated to their function as symbols. When Matisse reportedly salvaged a torso discarded by Maillol because it looked too much like an antique, his gesture demonstrates the tenacity of this link between partial figures and antiquity.

Another reason might be that if there is always something missing from an image, the only way to evoke completeness would be via an image that appears unfinished. What attracts

our look is what we cannot see, and we search the field of vision for what could never find a place there, the part lacking from visual reality. Perhaps this is why the Romantics professed an aversion to the 'finished' and sung the praises of the *non finito*, the unfinished. Knowing that the finished in fact could never be attained, its ideal could be aspired to only through unfinished things. In this sense, all art is unfinished since it can never satisfy the appetite of the eye: it can never show what the eye searches for.

The unbroken surfaces of Quinn's sculptures with their absence of detailed musculature come into the place of something bodily and broken, the events and illnesses that have given these figures their particular bodies. There is a sublime effect here, as the statues embody both the individual realities of their subjects and, through their formal features, the dimension of classical art and the symbol: if the reader will forgive the use of gateposts, we could say that their space is thus the zone between life and death, between the animate, living body and the mortified dimension of symbols.

If the uneasiness this produces can transform our relation to classical form, Quinn's work also challenges our perspectives on modern sculpture. Rodin is often seen as the key figure in the renaissance of the partial figure, with his celebrated focus on the incomplete body or body part. But whereas in pieces such as *The Earth 8* of 1884 or his *Male Torso*, Rodin's severance of limbs highlights an arrest of the modelling process, Quinn's figures seem fully sculpted: where the partialness of Rodin's bodies refers to the act of sculpting, Quinn's refers to the sculpting of amputation itself.

These pieces contrast with much of Quinn's earlier work, where the body is presented either as a compressed, shrunken

residue (the *Planck Density* series), a dripping, slimy fluid (*Paranoid Nervous Breakdown*) or a pure mirror surface. This new 'classicism', as we have seen, is a complex one, evoking not just the individual bodies of his models but also the nature of the partial figure as a symbol of art and ideal form. The pieces work to collapse the efficacy of a symbol and, in doing this, they evoke the whole question of the construction of our reality through systems of representation.

Although all works of art, since they take place in history and thus in relation to other works of art, form part of a signifying system or network, it is of special interest to explore the moments when a system as such, a set of rules, is applied to artistic production. The most famous example of this is probably the introduction of linear perspective, a system that brings with it its own prescriptions and constraints applied to the depiction of visual space and the creation of the illusion of depth. Its status as an artificial, symbolic system is perhaps why perspective has so fascinated psychoanalytic writers.

Perspective poses the problem of the relation of visible space to geometrical space, a subject that has generated a vast literature. When we learn the elementary laws of perspective at art class in school, this reduction of the visible to the geometrical is taken for granted. We fix a vanishing point and a point of distance and then make a grid to organize our picture. Using perspective fixes the position of the viewer, defined mathematically in relation to the geometrical grid. As Alberti prescribed, the artist must select a specific viewing distance, a fixed centre and a fixed position of lights.

In this way, so it seems, space becomes unified: it is reduced to a system of co-ordinates and there is only one place from which to look.

If we follow these rules, the picture plane is established and the frame becomes a window to which we bring our eye. This unification of space seems very different from previous forms of representation. In much medieval art, there is a multiplicity of vanishing points: parallel lines depicting separate objects don't have a common vanishing point, suggesting that we are viewing from several places, or at least have the possibility to do so. Visual space here is not unified but discontinuous, and it is a question why certain pre-Renaissance traditions in art such as the Islamic knew the optical rules of perspective but chose not to use them.

The use of linear perspective was often vaunted as the route to the natural representation of visual reality, and it has been associated with the popular idea of the reduction of light to geometrical lines rather than visual rays. As we saw earlier, the theories of vision that came with perspective seemed to make light invisible: the mapping of sight became confused with the mapping of space. Space became a uniform system of abstract linear co-ordinates, a container of objects and figures. The corporeality of light and the complex nature of the subject's perhaps fleeting look were banished from the theory of vision, and in the art forms that relied on the geometrical mapping of space, the viewer was confined to one ideal point from which to see. This stricture was so powerful that, even in the nineteenth century, pictures were often hung at an angle from walls so that the viewer looking up at them was in the correct, centred position, perpendicular to the picture plane.

Things, however, are by no means as clear-cut as the

above reconstruction might suggest. Note first of all that linear, central perspective forms only one part of a series of perspective forms: atmospheric perspective, for example, uses value changes to generate the sense of distance and volume, and colour perspective uses colour changes to create similar effects. Linear perspective on its own can in fact have a strange, 'unrealistic' effect. And to prescribe it as the dominant organizing principle of visual space may well owe more to seventeenth-century French theorists than to the Italian painters and theorists of the Renaissance.

Linear perspective formed just one part of a series of elements required to construct a picture. Indeed perspective was frequently used as a metaphor for visual order in paintings rather than as a simple set of rules for painting them. It often had the status more of ornament, used in the drafting of backgrounds and grounds for the painted figures to stand on. It was thus less the overriding schema of a picture than a part of it, and hardly the abstract container vaunted by modern theorists.

Similarly, Martin Kemp has argued that the perspective system of Alberti is not a consequence of the geometry of vision or the visual axis of traditional optics. This puts in question the received idea that linear perspective simply imposed developments from optics into art theory and practice. His perspective theory is about the craft of painting, not the act of visual perception. It is possible that Alberti's basic geometry of vision is in fact based on the viewing of pictures, or, at least, of evenly flat and limited surfaces. Painting, as Jeroen Stumpel suggests, becomes for Alberti a model for a theory of perception, rather than the other way round.

In practice, likewise, the use of perspective is often quite different from what a theory prescribes. Although there

ought to be an ideal point from which to look, many frescos and reliefs have an inaccessible centre of projection, so that the viewer has to use certain cues to infer where it is and then, perhaps, to imagine that they are looking from that point. Hence it is not uncommon for a viewer to assume that they are looking from a point perpendicular to the picture plane when that is not in fact the case. It has also been argued recently that many Renaissance works involve a deliberate discrepancy between the viewer's actual point of view and the virtual point of view defined by the perspective construction of the picture.

What such observations and arguments show is the necessity of caution in generalizing about the imposition of perspective, and they raise the question of why it has fascinated so many generations of scholars. If perspective had been the rigid dogmatic imposition that modern authors are telling us it wasn't, history might have become closer to its own rational reconstruction. The reduction of visual space to geometry and the imprisonment of the viewer to an ideal point make a lot of sense in terms of certain narratives of social and cultural history. We are reminded here of the art critic Clement Greenberg's infamous visits to the lofts of New York artists in the 1950s. Greenberg had the idea that contemporary painting had privileged, and ought to privilege, an aesthetic of flatness: inspecting an artist's canvas, he would order them, at times, to make it flatter. Rather than viewing the work and then deducing the aesthetic, he made his mind up about the aesthetic and then ordered his artists to conform to art history. If 1950s painting wasn't as flat as it should have been, and Renaissance linear perspective not as systematic, then, from the great perspective point of history, as Hegel said, 'so much the worse for the facts'.

The different insights into the history of perspective we have mentioned still suggest that even if perspective was not the neat system we want it to have been, there was none the less generally an ideal, mathematically defined point from which to view, occupied or not by the spectator. In that sense, an artificial, symbolic system assigns a unique place to the subject. And since the location of the vanishing and distance points will be determined, at least in the earlier systems of perspective, by the distance between the centre of projection and the picture plane, the artist has, in a certain way, been included in the picture, even if no human form is present there.

This reduction of the human subject to a mathematical point is evoked by the artist Patrick Coleman. As a child, he would survey the landscape through his bedroom window, imagining that he could instantaneously project himself to the furthest point. In the marvellous painted screen prints he would create many years later, the strange ubiquity of an iconic, ithyphallic St Sebastian figure situated on the horizon line thus takes on a new sense. Although Coleman himself may or may not be depicted in the scenes, the point of perspective is always there. This is the point from which the artist looks back at us.

If the laws of perspective prescribe an ideal point, and if this ideal point can embody the gaze of the artist, as we see in Patrick Coleman's work, how does the viewer's own look participate in the picture? Is it to be identified with the same ideal point or, as some theorists have argued, with the distance points? On a more general level, we can ask the question of how the tension between a seeing subject and the supposed reduction of visual space to geometry can be included within a picture.

Lacan found one answer in a curious vogue that fascinated many sixteenth- and seventeenth-century artists. This vogue is called anamorphic art, and it involved the use of the laws of perspective to inflect and question some of the implications of perspective itself. Perhaps the most famous example is Holbein's *French Ambassadors*, painted in 1533. We see the detailed depiction of two men facing the viewer, surrounded by the objects of vanity and knowledge. The figures are finely drawn, the perspective is impeccable. But in the centre of the picture, floating just above ground level, is a strange grey mass, amorphous and undefined. It is only when we move away from our position directly in front of the painting to a point oblique to the picture plane that this bizarre shape comes into focus to reveal a human skull.

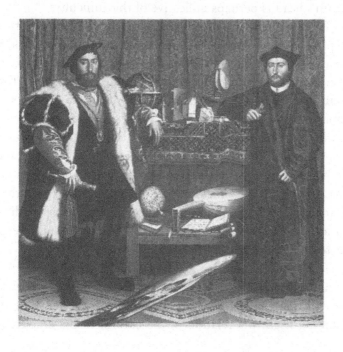

Anamorphic art involves mapping space with the traditional lines of perspective and then pulling these lines to a point removed from the central viewing position. The distorted image will become clear when the viewer moves to the point where these lines converge. Sometimes the whole image is painted or drawn in this way, and sometimes, as with the *Ambassadors*, just a part of the image.

Why should artists appeal to this strange technique? It clearly served, just like many more standard perspective constructions, as a sign of the artist's skill and dexterity. But there is something unsettling and problematic about it. The fact that in her book of more than two hundred pages devoted exclusively to an analysis of the *Ambassadors*, Mary Hervey devoted barely a couple of sentences to the anamorphic death's head is perhaps indicative of this difficulty.

The obvious explanation is a religious one. The painting depicts two worldly men surrounded by their worldly objects, and the death's head indicates the reality beyond their vanities. Hence it is the spiritual life that matters. The many anamorphic images that graced the walls of the monastery of the Minim order in Paris in the early seventeenth century included an anamorphosis of Christ above the high altar and nightmarish pictures of the saints in the cloister where the monks prepared for meditation. Beyond the visual world is the spiritual world and the pain that Christ suffered for us. Anamorphosis seems to be sending us a message about the folly of the material world: it directs us to something beyond the image.

The carefully hidden crucifix at the upper left-hand corner of the picture complements the skull with its promise of salvation and also, perhaps, indicates the function of painting itself: the relation of the curtain to the crucifix is

parallel to that of the painted surface and what lies beyond. Holbein's picture thus emphasizes the screen-like quality of the visual image. And by combining the presence of two viewing points, the one that makes the main image clear, the other that makes the anamorphic part of the image clear, it suggests that perspective is artificial. The technique that is supposed to render the visual world as it really is, to give the illusion of depth, becomes unmasked as merely a convention. As Descartes said, perspective is a lie, not a way of making representation exact, and it is probably no accident that the philosopher was a frequent visitor to the Minim monastery.

What you see depends on where you see it from, as if it were the viewer's look that actually constituted visual reality rather than simply recording it. There is thus no sense in trying to paint reality 'as it is' using the laws of linear perspective, since it is our own point of view that decides what is real and what isn't. Where the laws of central perspective and the apparent reduction of light to geometry supposedly aimed to regiment the viewer's participation in the picture, anamorphic art works against this, by using precisely the laws of perspective to do this. The seeing subject re-finds their place – not a pleasant one – in the world of vision thanks to the very practice that had removed it. Rather than *bringing* the eye to a depicted scene, it showed how the eye *made* the scene in the first place, how it was already included in the picture. As Lacan pointed out, anamorphic art reintroduced what the geometrical approach allowed to escape from vision.

If the central position of the viewer in linear perspective gave the illusion of an ideal position, the 'correct' place from which to look, anamorphic art showed that the picture was

much more than a window to which the viewer brought their well-defined gaze. At the moment at which Holbein's skull comes into perspective, we realize that it is looking at us. The picture is a trap that catches us, the empty eye sockets of the death's head reflecting back to us our own nothingness. Our own look is thus inscribed in the picture at the point at which the picture is looking at us.

This tension is brought out superbly in a famous scene from David Lean's film *Lawrence of Arabia*. Lawrence and his guide stop at a watering hole in the desert, two tiny figures in a vast, flat and uniform landscape. We see the horizon line beyond them and a few tracks in the sand, like some canvas with the rudiments of a geometrical grid prepared for painting. The guide is looking at the vanishing point in this strange and desolate space, and as we see his unease turn into anxiety, we realize that the vanishing point is in fact coming towards him: first a dot, and then, as it becomes clearer, a rider.

The relief they feel at finding water is transformed into terror: the plane geometrical space incarnated by the desert is not simply something the two travellers can look at, because it is in fact looking at them. And they shouldn't be there, with no rights to use the prohibited watering hole. The invisibility of the perspective plane, materialized here by the horizon line and tracks, is not empty: it looks back at them, just like the death's head that fixes the viewer in Holbein's painting.

The subjective dimension banished or, rather, regimented by geometrical mapping thus returns, and its effects are mortal for Lawrence's guide, who is killed by the lone rider the vanishing point becomes. The visual space that we map out by means of perspective seems to conceal this dimension,

yet it returns when the space starts to look back. In this process, something is always lost. When we see the skull in Holbein fix us, we lose sight of the rest of the image, and when we see the figures in focus, we lose recognition of the skull. Isn't this one of the lessons of anamorphic art, that we continually lose something in the field of vision?

Lacan went further in his discussion of anamorphosis. In a panoramic view, which perhaps owes something to the Vienna School of art history, he linked it in a series to archaic architecture. The function of this, he thought, was to house an emptiness, the emptiness created by the world of language and signs. With the invention of perspective, this emptiness became the illusory space of painting, and then, with Neo-Classicism, it moved back into architecture itself, which now drew on the principles of perspective from painting. The space of perspective governing painting was designed to create the illusion of depth, yet the practice of anamorphosis highlighted the artificial, symbolic side of the illusion. It was indicating that at the start is a symbolic system, an artifice. Lacan would no doubt have agreed with Frank Stella that 'the aim of art is to create space', and he could also have evoked many examples from outside the Western tradition.

Byzantine art is especially interesting here. Without the use of a system of central perspective, how could figures be shown to be interacting with one another? By using curved surfaces, a figure could be shown frontally or semi-frontally in relation with other figures depicted at another point on the surface. Since these curved surfaces could form vaults or enclosures, the physical, real space between them became included in the picture. Rather than the viewer being separated from the image by the picture plane, beyond which lies an illusory space, the

whole interior space of the church *becomes* the pictorial space. Similarly, when the pictures originally situated in niches had to be transferred to the flat walls of twelfth-century churches, painters began to include architectural features within the painted scenes themselves. Niches and other features would be painted in as the receptacles of the figures. The housing of emptiness that the architecture of vaults had incarnated now passed into the space of the paintings themselves.

But what of the look? Lacan's point was that the look is ultimately something separate from us, not simply the look of the Other that we try to protect ourselves against but also our own look when it is no longer a part of our everyday subjectivity. In the same way that anecdotes about Renaissance artists refer to their painting arm being a divine vehicle, so our own look can be possessed by something foreign, seized by desire and envy. Can this dimension ever really be included in a picture? Or is a picture simply the embodiment of our look in the first place? Is its fate to be reduced to a mathematical point or can it feature in visual art only once it has been torn away from the viewer, as in Holbein's anamorphosis? In Patricio Grose Forrester's tone drawing, reproduced below, we see a portrait of the artist, crisply drawn and carefully shaded, yet in the place of eyes there are two empty spaces that seem to protrude from the picture plane. These empty spaces are merely the effect of a lack of shading: the artist has not *drawn* anything there, yet created the blanks through the surrounding network of lines. A void is thus manufactured, just like that at the centre of a vase. In this sense, the drawing creates an emptiness, but one with a quite particular quality: the empty eyes seem to have a substance, to emerge out from the picture, to produce a strange, unsettling effect.

These blanks are substantial and tangible, and might invite us to ask the question whether the empty spaces are simply what the artist has not shaded in or whether they are a real part of the body: they seem, in fact, more physical, more present, than the rest of the body image visible to us.

In our relation to the visual field in which we expect to be able to recognize what we see, we are confronted with a barrier. If we take the recognizable and conventionally realistic nature of the drawing as a paradigm, Grose Forrester's work shows us that visual reality is built up around a void, which is created by the exclusion of the seeing dimension of the eyes. As we face the portrait, it is as if the blank spaces incarnate our own look, which has been separated from us, just as Holbein's skull produced a similar effect through the technical means of an anamorphosis. This theft of the look will always have an uncanny quality.

In the film *Dolores Claiborne*, Jennifer Jason Leigh looks into a mirror and sees only the back of her head as reflection.

The bizarre effect of this Magritte-like image is echoed in the moments in everyday life when we catch sight of our own image and this image *is not looking at us*: if we see our reflection without initially recognizing it, for example, or when we see ourselves on CCTV without expecting to. This is the basic psychoanalytic notion of the look that Lacan introduced: our specular image is torn away from us and, crucially, our look is no longer looking at ourselves. There is a separation of the look, the emergence of our look as an object, outside us, as the video work by Susan Morris that we discussed earlier showed so clearly.

In Grose Forrester's picture, the look is embodied in the absence of eyes and, in a sense, conventional, recognizable eyes are not suited to convey the dimension of the look as separate from us, the viewers. A sculptural object can sometimes produce this effect, as we see in a work by Sarah Lucas, in which the viewer is forced to stare through a peephole to glimpse the cast of a male arm. Although the arrangement of this piece would seem to rely on and perpetuate the classical model of contemplation, in which a single eye is focused on an isolated artwork, the arm itself upsets the balance of subject and object: the cast is moving up and down, miming the act of masturbation. The sculpture thus looks back at the viewer. Where the presence of the peephole evokes the sexual look and masturbation of the voyeur, the moving arm places them back in the picture. Our own sexual, scopic activity stares back at us, embodied in the sculptural object.

Doesn't this separation of the look give us a clue to the really troubling dimension of the mythological and literary motif of the double? The fact that we see our own image failing to obey the laws of symmetry established by the framework of the mirror in which we normally encounter it

may be disturbing, but it is the *independence* of the double's look that transforms this into anxiety. The double shows us our own look separated from us, torn away from the mirror framework. And indeed, doesn't the folklore of the evil eye echo this emphasis on independence? When the Church Father Basil discusses the malevolent eye, he suggests that demons press the eyes of the envious into their service. Although it is our eyes that are in question, there is something alien that takes possession of them, separating them from us.

Lars Von Trier's film *Dancer in the Dark* illustrates this separation of the look, the independence of the look from the body image as such. Björk plays Selma, a young woman who is going blind and is saving up desperately to pay for an eye operation for her son to prevent him from meeting the same fate. Her savings are stolen by a man she considers a close friend and, in the ensuing struggle, she kills him. Imprisoned and awaiting the death sentence, she insists on keeping the facts of the eye disease secret from her son: knowing about it, she thinks, will increase his worry, and jeopardize the success of the operation. When the character played by Catherine Deneuve screams at her that by withholding the story of what really happened she is depriving her son of a mother, Selma screams back that it is only her son's eyes that matter.

The film uses cardboard characters and deliberately artificial dialogue, as if the actors are reading off cue cards, to create a strange, unreal effect. True to his times, Von Trier realizes that to get to what's most real, you have to start with what's most artificial. And what's most real here involves what is most precious to each of the characters: for Selma's friend who steals the money, it is the bundle of

banknotes; for Selma's suitor Jeff, it is Selma; for Selma, it is her son's eyes. Each of the characters in the film is defined by what matters most to them, what they will ignore everything else in order to get. These different forms of blindness define the relation of man and woman to their object of desire in its most reduced form.

And what we find with Selma's defiant act of sacrificing herself is a relation less to a person than to a person's look. If Selma matters to Jeff *as Selma*, her son matters to her less as a son than *as a pair of eyes*, as the scene where Catherine Deneuve confronts her shows so clearly. She is not interested in the idea that by dying she is depriving her son of a mother: the most precious object for her is this look, the look outside herself which is situated in her son. The film's controversial use of music also illustrates this process of reduction. When Selma is faced with the most appalling horror, she daydreams herself into a world of Hollywood musical. The brilliance of the film-maker here lies less in the exposition of the idea that we use music to protect ourselves from pain, but in the particular way in which Selma's musical daydreams emerge. The songs take their cue from meaningless, arbitrary sounds: the scratching of a gramophone needle next to the corpse of the man she has killed, or the noise of graphite on paper as she stands trial for murder.

It is not just a question of the unbearable experience of pain and the musical daydream, but the fact that there is something *in between*: the ineffable sounds that are the real barrier between these two worlds. The fantasies are constructed out of the horrific void from these tiny, senseless sounds, showing how our fantasy activity is built up from elements that have no meaning in themselves. They embody the pure dimension of sound, the voice separated from any

meaning or signification it might carry. Hence, towards the end of the film, the musical props that have saturated Selma's fantasies dissolve: all that's left is the pure voice, convulsed with pain, a last umbilical cord between mother and son. When Selma gives up everything for her son's eyes, we find the same logic. Everything becomes reduced to one senseless object – the eyes – as if the look has become separated from the human dimension of affective relations, the mother–son relation that Selma renounces and, indeed, from any feelings her son might have.

We saw earlier on how the child's relation to the mother or care-giver will play an important role in the dynamics of looking. The traditional emphasis here is on the feeding rela-tion at the start of life, but looking and feeding are in fact linked in a number of ways. When infants are feeding, they spend a lot of time looking not at the breast or nipple but at the mother's face. In fact, researchers have been surprised at how much of feeding time is actually taken up with looking. One way of explaining this is to evoke the discontinuous nature of feeding: the only thing that is certain about it is that it will stop. In contrast to the oral relation of feeding, the scopic relation of looking promises continuity. The mother's face can be fixed even if the presence of the nipple cannot.

This explains why people eat popcorn compulsively when they go to the cinema. Why can't they just watch the film? At dance or at the theatre, nibbling is more restricted, but at the cinema popcorn buckets get bigger and bigger. The key here lies in the relation of popcorn to the image. When

people eat popcorn, they don't eat a bit, then stop, then eat a bit more later. They just shovel it in non-stop, to persuade themselves that feeding is a continuous as opposed to a discontinuous process. And this all happens when they are confronted with the image in one of its most purified forms: film.

Eating and images are entwined here. As the artist Olivier Richon once pointed out, speaking of photography, the camera is not just a dark room: it is also a dining room. The effort is to cover over the terrible fact that feeding is in fact something that stops. Images offer the solution. And what better cover than the one part of our reality, the visual field, that seems to be *continuous, unbroken*. Maybe this is why most people spend their lives watching television. Art can challenge this. When Cézanne left bare patches on his canvas uncovered by paint, he turned away from the tradition of avoiding any break in the continuity of the painted surface. Such art shows that the visual field is in fact discontinuous, perhaps just as Leonardo suggested with his broken background to the *Mona Lisa*.

We argued earlier that one way of understanding the *history* of art is as the history of finding new ways to evoke what is missing in the world of images, the absence that makes us look. If the inclusion in visual art of half-seen objects was one moment in this history, anamorphic art and the work of Cézanne are two others. They show us that we always lose something in the field of vision. There is always something that we can't see. Perhaps this is why most people prefer watching television to looking at art, and why they don't sell popcorn in art galleries. Images, perhaps, are supposed to be working against their usual function.

In what other ways does art show us that the visual field is not continuous? There are plenty of obvious examples,

ranging from the broken and disparate surfaces of collage to the uncomfortable experience of Op Art. Changes in artistic style may be linked to this problem. If something is lost in the register of the visible, an artwork might try to bring it back. In the movement from one work to another, we may get a sense of the problem the artist is grappling with. Take, for example, Bacon's celebrated series of Screaming Popes. Since the artist executed more than thirty of them, we might think that he was trying to *do* something, to capture something. The simple fact of their iteration suggests an effort, the encounter with some obstacle that set him painting again. We could ask, then, what he was trying to capture, and, equally significant, why he stopped painting them.

There are lots of theories about these pictures. Bacon often spoke of his obsession with Velázquez's 1650 portrait of Pope Innocent X and, according to one recent theory, the Velázquez Pope bore an uncanny resemblance to Bacon's father. Since this father was a man prone to screaming at people, Bacon's Popes are screaming. The Screaming Popes are all versions of the image of an angry father. When David Sylvester suggested something of this sort to Bacon, by pointing out to him the link between the word 'Pope' and the word 'Papa', the painter replied that he didn't really understand what Sylvester was on about. And if it has also been remarked by a family member that Bacon's father actually looked nothing like the Velázquez, why not take the painter's response seriously? Without ruling out the possibility of some link to the father, we would be hard pressed to argue that Bacon painted his Popes because of a visual similarity.

If we wished to follow the psychobiographical route, what else could be conjured up? Apart from the Velázquez,

two other images were to haunt Bacon. First of all, the scene of the screaming nurse from Eisenstein's *Battleship Potemkin*, in which a baby in a pram falls away from its nurse, followed by the image of a man striking a blow with a sword. When Bacon travelled to Berlin after he left Ireland at seventeen, it was not the decadence and sexual commerce that left its mark on him, but the isolated image from this film. The other image to captivate the painter was Poussin's *Massacre of the Innocents*, in which a soldier strikes a child as he presses his foot into its neck, and a mother desperately tries to stop him. He became mesmerized by this painting after he saw it at Chantilly directly after his stay in Berlin, and it contains what Bacon would call 'probably the best human cry in painting'. One might think that the echo of 'innocent' from *Massacre of the Innocents* to the Velázquez *Pope Innocent* can't be mere accident. Perhaps the Pope mattered more because of a word than any visual likeness to his dad.

Bacon painted versions of the *Potemkin* image, and it has often been argued that the scream of the Screaming Popes is in fact the scream of the *Potemkin* nurse, a still of which Bacon kept on the wall of his studio. But what is fascinating is the fact that both images – the Poussin and the *Potemkin* – involve exactly the same elements: a woman screaming, a doomed child and a man striking a blow. Much could be made of this convergence in terms of Bacon's life and manners. Poussin's child, for example, is not simply doomed, he is very graphically gasping for breath, a detail that becomes important when we learn that Edward Bacon, Francis's brother, had died of an asthma attack (or a respiratory illness). If we are looking for a link to the father in Bacon's art, it is through this image of gasping for breath.

Bacon would later say that the only moment when he saw his father show any true emotion was at the death of this brother. It takes on a key value since it constitutes the image of what it takes to capture the passion of the father. And Bacon himself, who suffered from asthma from an early age, would recall the one tender image of his father administering morphine to him during an asthma attack. Gasping for breath thus functions as a route to the father.

Do we now have an answer to our question: Why are Bacon's Popes screaming? Is it for the same reason that the nurse in *Potemkin* is screaming, the lost child? It is significant that the series of Screaming Popes stops screaming once Bacon has painted his nurse from *Potemkin* in 1957, suggesting that where the scream really belongs is with the nurse and not with the Pope. The scream, perhaps, has gone back to the right place. Another way of looking at it is to take Bacon seriously when he claims that the Popes aren't necessarily screaming. Perhaps they are gasping for breath, implying a link with the breathing difficulties and what they signify in relation to the father. The *Potemkin* image and the Poussin portray the scream as the acoustic cord linking mother and child, yet Bacon's own history might suggest that gasping for breath is in fact the link between father and son. And indeed, the mouth in Bacon's art is ubiquitous: it is obscured or smudged, as if Bacon were trying to paint something beyond it, something that, as it emerges, disrupts the very organ through which it passes, the breath, as it is obstructed, contorted, expelled.

If one were to follow this line of thought, the key painting would be not the *Potemkin* nurse, considered as the last in the Pope series, but rather the very curious and hardly ever mentioned portrait of man with child, uncannily similar to a

Pope, which Bacon paints round about the time the Popes stop screaming, as it would suggest this motif of the bond of father and son.

But do these threads really help us in our efforts to explore the question of the visual field? Rather than linking the scream to the mother or the father, why not leave psychobiography aside for a moment and see the cry itself as the central character in the drama of this phase of Bacon's art? Instead of claiming 'It's the mum', or 'It's the dad', why not hypothesize 'It's the cry'? And then the key question becomes that of following the history of this cry in Bacon's painting. The question of the narrative of the cry replaces that of the narrative of the family, and we have to ask: What happens to this cry once Bacon's Popes have stopped screaming?

Bacon started painting screams around 1941, and in the Pope series the scream moves from one picture to another, situated first of all in the mouths of the Popes and then, by 1957, in the mouth of the nurse from *Potemkin*. These almost obsessive variations on the same motif suggest that the problem for Bacon was in situating the scream, in giving it the right place in his images. Although it seems to be localized in the mouth, this becomes less and less clear, and in *Pope III*, it emerges from behind the figure of the seated Pope, as if the scream were ultimately something that was separated from the body, outside it.

Indeed, all of Bacon's Popes show the difficulty, the impossibility of lodging the scream in the body: it is something that overflows, disrupting the body's unity – as if the human body and the scream couldn't be in the same place at the same time without some terrible contortion, without the body being wrenched apart by the cry. One could call the Pope series, from this perspective, 'Screams in search of an author': the problem is in attributing them to a body, which is perhaps why the scream keeps moving from figure to figure.

Now, after painting the screaming nurse from *Potemkin* at the end of the Pope series, Bacon said, 'I hope it is the last scream', and although it does seem that the Pope figures stop screaming, the scream continues its trajectory in Bacon's art, but in a very different form. What happens when the Popes stop screaming? Something very curious. Bacon paints a series of Van Gogh portraits, radically different from his earlier work, replacing his usual monochrome backgrounds with a fiercely coloured brushwork which includes both the human figures and the backgrounds.

Whereas, in the Pope series, it was the figures themselves that were the focus of colour and brushwork, now it is the

whole canvas, which becomes covered in a kind of frenetic, glutinous impasto. Why not see a link between the disappearance of the scream in the Pope series and the emergence of this new technique? If the Popes stop screaming, it isn't because they're any happier, but because the scream has now moved into the paintwork itself, its acoustic vibrations disrupting the surface of the canvas, as if the scream, impossible to capture by painting the mouth and the body, has been shifted to another register, that of the very texture of the painting.

And if the uniform impasto of the Van Goghs ends, in its turn, the cry takes on another form. Critics often see the smudged forms and opaque masses that seem to sprout from Bacon's later figures as a sort of signature, the meaning of which remains obscure: a surplus or remainder exceeding the body, going beyond the limits of the figure. Which is indeed exactly the tension found in the Pope series, where the cry fails to fit the contour of the body. After the Van Goghs, the scream continues its search for representation, but now it has become a smudge, as we see in the substantial shadows, blurs and opaque masses which haunt Bacon's figures as their strange doubles. All of these innovations form a series – from the Screaming Popes to the violent brushwork of the Van Goghs to the glutinous residues – a series that is showing us how the body is the container of something more than itself, something that, in a sense, has no home, a cry that is exiled from the body and that searches, in Bacon's art, for a place.

The passage from one set of images to another is thus linked to the problem of including something that resists being turned into an image. It is the impossibility of rendering the cry that gives a direction to the sequence of works, as if

the effort to include it would continually demand a shift in register. The idea is that when an artist is confronted with this problem of giving a form to something that by definition does not have a form, it frequently results in a change in the register of *what the artist is working with* rather than simply a change in *what the artist is supposedly depicting*. Picasso's turn to sculpture might also be evoked here, emerging at important moments of impasse, or de Kooning's decision to stop painting his *Woman 1*.

De Kooning had spoken of wanting to spend his entire life on a single painting, and *Woman 1* was repainted daily for almost two years. After some more unfinished *Woman* paintings, he produced a canvas in 1955 depicting a huge woman with the Washington Memorial for a nose and the Jefferson Memorial for ribs. Soon, the woman herself has become absorbed into landscape in a new series of rural scenes. Like Bacon's scream, de Kooning's woman was painted and repainted obsessively, before shifting into another form. Rauschenberg was clearly wrong to say that 'painting the *Woman* was a mistake. It could never be done.' He failed to see that this is exactly the reason why it *had to be done*. The impossibility of completing his *Woman* was what compelled him to generate the sequence of versions, and then, to elaborate this failure in another organization of images, but this time with the figure of woman apparently absent. The key is that the shift occurs once one approach to the problem of giving a form to something that has no form has exhausted itself.

This change in register is what Sartre picks up on in his discussion of voyeurism. The voyeur is suddenly surprised by the snap of twigs underfoot: he is caught in the perverse act of looking that materializes his desire. The noise of the

twigs dispossesses him of his look, as it now stands outside him, yet in the form of sound. The ungraspable, opaque dimension of desire is embodied in this shift in register: from that of seeing to that of hearing. The impossibility of giving an image to the desiring look translates into sound, just as Bacon's scream translates into the paintwork of the Van Gogh series.

We could put this argument another way. What the psycho-analytic approach suggests is that visual reality is based on an exclusion that is less the result of a prohibition than an impossibility. The world can retain a consistency for us not because society says that certain things need to be covered up or taboo, but because they actually cannot pass to the level of visualization or even ready imagination. With Bacon, for example, the impossible representation of an unidentifi-able cry is what collapses the co-ordinates of visual space, before passing into the paintwork itself. And if the look is profoundly disparate from the field of the image, it has to be represented in another register – such as sound. One space thus depends on another, impossible space, and one could see the history of art as the story of the successive efforts to make one space cohabit with the other.

Could Bacon's scream be situated in the same series as Leonardo's famous smiles? They are both features that critics have pondered endlessly, giving them an enigmatic, iconic status. Since we can find the same smile on the lips of the artist's *Mona Lisa*, *St Anne* and *St John*, was it a special signature of Leonardo or merely his own version of a smile that had its precedents in both painting and sculpture? The

smile can even be found documented in a contemporary manual for ladies, which advises them 'to close the mouth at the right corner with a suave and nimble movement, and to open it at the left side, as if you were smiling secretly . . .'

Medics, perhaps unaware of this prehistory, have seen in it the rictus of the asthmatic, the eagerness of the hard of hearing or a sign of the apparently placid state of pregnancy. Freud thought that it evoked for Leonardo the 'bliss and rapture which had once played on his mother's lips as she fondled him'. The enigmatic status, however, of Leonardo's figure is something of a product of the nineteenth-century imagination. It was only with the emergence of the cultural figure of the *femme fatale* and commentaries on the painting by the likes of Théophile Gautier and Walter Pater that the *Mona Lisa* started to embody a mystery for its viewers. Their exceptionally purple prose endowed Leonardo's figure with all the qualities of a contemporary *femme fatale*. Her smile was sinister, dangerous, unfathomable, opaque and lethally beautiful. With the iteration of such descriptions, the newly available engravings of the picture acquired a freshly minted history. The cultural emergence of the figure of the enigmatic and deadly woman turned the painting into something new. Before this period, the smile didn't seem really to mystify anyone.

The sustained efforts of writers such as Gautier and Pater had endowed the *Mona Lisa* with a special status: she was not just enigmatic, she had become a *symbol* of the enigmatic. The frenzy of advertising using her image that followed the theft perpetuated this strange feature. Her smile could be interpreted as a response to the thought of the delicious chocolates contained in the box her image graced, yet as an icon of the enigmatic, her desire was always elsewhere, never

satisfied by any one object or interpretation. She could advertise a product, but only on the condition that she *also* advertised dozens of other products at the same time. Her smile had come to embody the gap between desire and its satisfaction by any one empirical object.

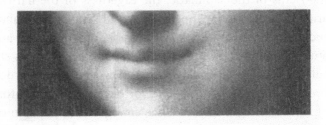

The elevation of the *Mona Lisa* and her smile into an icon of mystery shows us how interpretations of the painting tell us more about the culture and interests of its commentators than about Leonardo's intentions. As Kenneth Clark said, 'Leonardo is the Hamlet of art, whom each of us must re-create for himself.' There is none the less something rather attractive about linking the hypothesis that Leonardo's sitter was hard of hearing with the well-known propensity of the artist to amuse his companions with ribald stories and jokes so as to produce the facial expressions he desired to sketch. As he told one joke after another, the lady strained eagerly to hear, perhaps relaxing into her celebrated smile once she had given up any thought of following the artist's patter.

Leonardo was also prone to arrange entertainment for his sitters, and Vasari tells us that 'while he was painting Mona Lisa, who was a very beautiful woman, he employed singers and musicians or jesters to keep her full of merriment and so chase away the melancholy that painters usually give to

portraits'. Vasari's unreliability as a historian should not dissuade us from imagining that Leonardo's sitter was looking at something, and it is remarkable that no one has seriously argued as yet that, given the artist's fascination with all things phallic, he was exposing himself to her.

How else, one might ask, could one explain the strange mixture of tenderness and contempt that characterizes her smile? It is clear that Leonardo was someone who wanted to excite the other's look. If we give a sexual significance to his interest in flight, we should not forget that Leonardo was not simply someone who wanted to fly, but someone who wanted to be *seen* to fly: 'The great bird', he would write in a note, 'will take its first flight from the back of its Great Swan [a hill near Florence]; it will fill the universe with stupefaction, and all writings with renown, and be the eternal glory of the nest where it was born.' The artist here is someone who is looked at, who is showing something to a world that gasps in wonder at his achievement.

We can find the same dimension of exciting the look of the other in a strange story told by Vasari. Leonardo's father commissioned his son to paint a shield belonging to a local artisan. The artist created a bizarre arrangement of lizards, crickets, locusts and all manner of repulsive fauna to create a beast that, according to Vasari, was 'altogether monstrous and horrible'. The potential of a shield to terrify its beholders was taken to an extreme by Leonardo. When his father arrived to collect the shield, Leonardo had darkened the room, carefully fixing a light to illuminate the horrible chimera. His father's terror was so great that afterwards he contrived to buy another, more conventionally decorated shield on his way back home to present to the artisan, telling him that this was the work of Leonardo. This peculiar story

may well be apocryphal, but it resonates with much of what we do know about the artist: what it shows, once again, is his desire to produce a look, perhaps an anxious one, in his spectator. In the aspiration to flight, this is achieved through a phallic spectacle: in the Vasari anecdote, through something more gruesome and undefined.

The link between the famous Leonardo smile and the phallus emerges if we compare his painting of *St John* (left) with the little-known and recently 'discovered' sketch *The Angel in the Flesh* (centre). The *St John* picture features an androgynous, curly-haired youth, sporting an enigmatic *Gioconda* smile, who is pointing his finger upwards. *The Angel in the Flesh* shows a similar androgynous youth, a similar smile and a similar finger pointing upwards. But, in contrast to the *St John* painting, Leonardo has provided his youth with a remarkable feature: as he faces us, we see, right at the front of the picture, an erect penis.

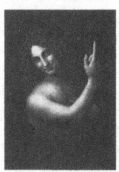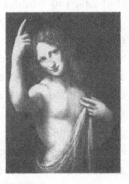

This shocking sketch also presents a model for the lost *Angel of the Annunciation* (right), in which we find the pointing youth and the veil that features in *The Angel in the Flesh*. We thus have a series: the youth with exposed penis,

the pointing angel Gabriel and the saint. The similarities between these three works are too great for us to deny any link between them, and Bradley Collins has discussed them carefully in relation to Freud's arguments about Leonardo. To start with, the artist shows a frontal, pointing angel rather than the traditional pairing of Gabriel and Mary. The novelty of this conceit, which Kenneth Clark described as 'audacious', involves the direct inclusion of the spectator in the picture: as Gabriel brings the news that Mary will give birth to the Christ, he faces us, thus putting us, and, arguably, the painter, in the position of Mary. As Collins points out, 'When working on the picture, Leonardo would have occupied this position himself. While gazing at his own creation, he would have played the role of the future mother entering into communion with a beautiful, smiling boy.'

With the inclusion of *The Angel in the Flesh* into this series, a youth shows his penis to a mother, but the sketch, it seems, did not become a painting: the phallus remained hidden. Collins's interpretation, which puts Leonardo in the place of the mother, is very Freudian. Freud had argued that as Leonardo's intense love for his mother became repressed, he identified with her: this meant that he would choose his love objects, as it were, from her place.

The boy that he had been for her would become his own object of adoration. He would love them as his mother had loved him. And in the sequence of pictures we have been discussing, the beautiful boy is depicted for a mother's gaze that is unseen, but situated logically in the place of the viewer. Perhaps Duchamp et al. were not too far from the truth in suggesting that the *Mona Lisa* herself was in fact the image of Leonardo. And perhaps it was more than accident that after the recovery of the stolen painting in Florence in 1913,

it was put on temporary display at the Uffizi not in the room devoted to the work of Leonardo, but in that devoted to self-portraits.

This brings us back to the idea of a dynamic of looks. If we take Freud's argument seriously, even if the look of his figures was his own, Leonardo was also looking from the place of his mother. There is thus no unitary subject, no single, subjective look: rather, there is an intertwining of looks, of which we are perfectly unaware. The look of someone else becomes incorporated as our own point of perspective.

We can find another illustration of this in a story Louise Bourgeois tells about a strange vicissitude in her relations to her wardrobe. Taking a break from the ardours of sculpture, she is occupying herself with her clothes, consisting of a collection of blouses hanging on one side of a rack, and of coats on the other. The coats reached down to floor level, the blouses only halfway. Suddenly she is seized by a fury towards the blouses, which seemed appallingly short, and is overcome with the urge to throw them all out. Why this moment of domestic fury? What had the blouses done to incur such wrath?

The answer lies in the point of perspective. In the midst of her agony, she remembers the moment her father had turned to look at a little fur wrap she had once possessed. 'You bought that little fur jacket?' he had asked. 'Couldn't you afford the whole coat?' He saw it, Bourgeois said, as a coat cut in two. 'I imagine the whole coat that would have pleased my father. It would have been long and flowing. I experienced the wrap the way he had – as cheap, a way of saving money. The wrap was a jacket cut in two.' The blouses were too short, seen from the perspective point of the father, and as the attack of passion shows so well, this perspective point had been incorporated by the daughter.

This is the condition that Piaget gave pride of place to in his map of human development: we can become fully social beings only when we have the ability to see the world through the eyes of someone else. In one of a series of experiments, Piaget used a three-dimensional model of three mountains and placed a doll at certain points. A child was then asked: What does the doll see? Up to a particular age, children do not usually answer 'successfully'. On the contrary, they tend to give as their response their own point of view: it would seem as if they have no sense of what the scene would look like to another party, embodied here by the doll.

But when this experiment is performed in a slightly revised way, the results are rather different. In a later version, the mountain scene is replaced by two intersecting walls in the form of a cross, to produce four partitioned spaces. Instead of a plain doll, the experimenter chose one representing a little boy and the other representing a policeman. The policeman is placed at the junction of two walls, so that two of the spaces will be visible to him and two opaque. The little boy doll is then placed in various spaces, and the child asked if the policeman can see him. A second policeman is then introduced, and the child asked to hide the little boy doll from both of them, a task that supposes the appreciation of two external viewpoints. And, in a result that would have surprised Piaget, nearly all of the children performed their task correctly.

Now, the usual way of explaining the discrepancy between the two sets of results is to claim that Piaget's subjects did not really understand what they were supposed to do. Or that the situation devised by Piaget made no sense to them, being too abstract, whereas the later experiment

introduced states that they were familiar with, such as the state of hiding or being found out. Yet the key to these studies must lie in the difference between the eye of a doll and the eye of a policeman: the one offers only the counterpart of the child, a kind of mirror, whereas the other is symbolic, a form of the Other, something situated in an entirely different register from a simple doll. And it is the incorporation of this point of perspective that the children seem to achieve from a very early age. Like Leonardo, they make the look of someone else a part of their own look on to the world.

This dynamic of looks might shed some light on the split between art and science that so intrigued Freud in his Leonardo book. If the aspirations to flight would make Leonardo himself the object of wonder, the paintings, although reflecting glory on their creator, would shift the gaze away from the man himself. This might suggest that the position of scientist, in the sense of creator of flying machines, would be more difficult to occupy, a place that could be aspired to but best not reached. And indeed, a focus on the *person* of the creator tends to bring with it a whole host of problems. Andy Warhol once said that he wanted to 'be Matisse' but, as Harold Rosenberg pointed out, there is no evidence that he was ever interested in Matisse's paintings. Artists become public figures, more important for providing a spectacle than for their works: as Rosenberg said, 'We admire the artist as a celebrity, while he deliberately creates banal works that cannot compete for our attention.'

And yet, although this identity as public figure may be cultivated by many artists, it is a fact that their excesses and pantomime are frequently less an attempt to remain in the limelight than an often catastrophic reaction to having been

in it. If artists start behaving badly when they've made it, the comedy of the artist as public figure is sustained by the very effort to cope with having become one. How, after all, can anyone live up to an identity that is given to them by others? And especially if this identity is their own proper name that has now become a label or trademark. The effect of division that this sort of baptism introduces is never easy for an artist to live with, despite whatever they might happen to tell you about it.

If it was possible for the children of the psychologist's experiment to identify with the point of view of a policeman so quickly, would that make it easier for them to commit any number of crimes? If they knew what the policeman could see, they would surely know how to avoid his gaze. In practice, in fact, identifying with the policeman's point of view makes most people have a sense of guilt rather than a passion for crime. When Peruggia handed over the *Mona Lisa* to Geri that day in Florence, did he know that the police were already closing in, or had he failed, at some level, to see things from the point of view of the other? Commentators have always been amazed at his naïvety, but it is also possible that his lack of any obvious paranoia meant that he wanted to be caught. Yet how could so many detectives have failed for so long in apprehending their culprit?

When the alarm was finally raised at the Louvre, hordes of policeman descended on the museum, blocking off all the exits and searching everyone who remained inside. Needless to say, they initially found nothing, apart from an insight into the private lives of its staff: the regular guard had stayed

at home as one of his children had the measles, his replacement had gone off to smoke a cigarette in the toilet, and a porter at the Cour Visconti entrance had been enjoying a nap in the sun under the shade of a red parasol. Yet all of these little details led nowhere. People outside the Louvre were seen behaving suspiciously – walking in an odd way, chewing gum strangely or carrying bulky packages – but these were all dead ends. From an artistic point of view, the theft had therefore been a real success: the invisible details of everyday life were suddenly being seen by hundreds, perhaps thousands, of people in a new way. It had needed no Van Gogh to transform these trivial, ordinary aspects of human activity into something new and meaningful: all it had taken was the theft of a painting.

The fact that a painting wasn't there had made people look at things in a different way. Everything that was once invisible became the object of a look, a fact that makes the theft of the *Mona Lisa* a work of art in itself. The look became mobilized when an absence was produced in the network of reality, just as the missing painting had functioned for Ruth Weber. The theft might not have made many people *create*, but it certainly made them *look*. And doesn't this tell us something about the peculiar frenzy of conspiracy theories that is such a feature of our time? Even today one can find theories doing the rounds on the Internet about the theft of the *Mona Lisa*: Peruggia, we learn, was just a pawn for the mysterious *Il Signore* who had masterminded the whole crime from the start. The key to understanding this phenomenon is to see the *Mona Lisa* not as a painting but as an icon, a symbol of painting. Now, if the network of reality includes a network of symbols, the mesh of privileged signs and images that function like quilting points in a

culture, how is it possible for a symbol simply to drop out?

If a human being dies, certain rites are carried out and, it is hoped, a mourning takes place. But if a symbol dies, these measures are never enough. Symbols, after all, take on their value only due to their place in a network of other symbols. When a human being has attained the status of a symbol, like Gianni Versace or Princess Diana, their disappearance can never be understood as simply the result of a contingent and tragic turn of events. It is because they function in civilization as symbols meshed into a network of symbols that, to make sense of their absence, the whole register of other symbols has to come into play. This is called, in ordinary language, a conspiracy theory, the use of the vast network of symbols (the State, the Secret Service, the Mafia) to fill in the gap created by the removal of a symbol. When a symbol drops out, there might not have been a conspiracy, but there *has to be* a conspiracy theory.

No one will ever be able to disprove conspiracy theories for this reason: as the only logical response, you can get rid of one element but another will roll into its place. If it wasn't the Church, it was the State. And the same holds true for the theft of the *Mona Lisa*. How could anyone make sense of the fact that the most sophisticated and sublime of all objects was lifted in a gratuitous act by what appeared to be the least sophisticated and sublime of all humans? The chasm between these two poles will no doubt remain just that, and will forever invite the injection of meanings. But what about the policemen? Louis Lépine, the chief investigator, bore an uncanny visual resemblance to Sigmund Freud, yet, despite this credential, he found nothing. Was it the fact that he was searching for a mastermind that stopped him from finding a humble thief?

Freud Lépine

Peruggia had in fact been arrested more than once before the *Mona Lisa* investigation, and a clear set of his prints was available in the once cutting-edge classification system established in Paris by the forensic expert Alphonse Bertillon. Bertillon certainly seemed to be the right man to have on the case. He had been responsible for the first ever conviction for a murder based on prints alone, and his talents for identification were legendary. Curiously, his own identity was less certain. After Bertillon's birth, his father was dispatched to register the new arrival. But on reaching the local town hall, he realized that he had forgotten the name he and his wife had chosen for their new child. He remembered that it began with an 'A', and in his confusion the name 'Alphonse' was produced, rather than the previously agreed 'Alfred'. Thus, at the dawn of the life of the man who would devote himself to creating systems for finding names is a point of forgetfulness: the absence of the right name.

Bertillon's later success in finding people was markedly

absent in the case of Peruggia. Since an inside job seemed more than likely, everyone who worked at the Louvre or who had worked there in the recent past underwent questioning and had their prints taken. Peruggia was on the list, yet failed to show up for his appointment. An Inspector Brunet was finally sent to question him, and when quizzed as to his whereabouts on the morning of the theft, it turned out that Peruggia had arrived at work two hours late. He claimed that he couldn't really remember what he'd been up to, but that probably he'd been out having a good time the night before. Brunet noted that this response was far from satisfactory, and advised further questioning. But this suggestion went unheeded: Brunet's report lay forgotten in the mass of documents accumulating at police headquarters.

Yet Peruggia had been a member of the team putting works like the *Mona Lisa* under glass at the Louvre less than six months previously. Examination of the crime scene revealed that the culprit must have had an inside knowledge of the way in which the picture was hung and framed, as it had been removed from its frame with such speed and dexterity. A letter to *Le Figaro* from a professor at the Ecole des Beaux-Arts called for a renewed scrutiny of all those who had put works at the Louvre under glass, yet Peruggia somehow managed to slip away.

Even the prints remained unexploited. In Bertillon's system, despite a database of some 750,000 prints, access to individual specimens relied on a complex process that involved other variables such as height and facial features. These would serve as guidelines before proceeding to the fingerprints themselves, with the right-hand prints given priority. The fantastically clear print discovered by Bertillon on the abandoned frame at the Louvre was clearly that of a left

thumb, yet no one bothered checking Peruggia's left print with the only real clue the thief had been generous enough to leave at the crime scene. The Argentinians were proud to point out that although they had adopted the Bertillon system, they had modified it in such a way that if the *Mona Lisa* and its thief had been in Buenos Aires, an arrest would have taken days, not years.

What was the barrier here that separated crime from justice? When the popular press set to speculating about the identity of the thief, although they considered the possibility of a Louvre employee or a madman, it was widely believed that this must have been the work of a millionaire. Not just someone with brains, but someone with money, and enough money not to be lacking any of the usual objects that society deems desirable. The tenacity of this assumption is telling. It shows that the iconic work of art is something absolute, beyond the register of tradable goods, and also that a very private enjoyment is involved. When Crown gazes at the Monet painting he has just stolen in the remake of *The*

Thomas Crown Affair, he is shown sipping an indescribably fine wine in the comfort of his luxurious study. The artwork is a pure object of enjoyment here, savoured, it seems, for nothing beyond itself. The distinction elaborated by Augustine between use and enjoyment, as the criteria to distinguish the forms of love that lead us to the appreciation of God, loved 'for no profit outside of Him', finds a scandalous, secular apotheosis here.

The theological distinction between use and enjoyment has moved squarely into the field of aesthetics, and frames the very concept of art theft itself. For the popular press, the *Mona Lisa*'s thief couldn't possibly sell the work due to its celebrity, so it takes on a special value: the value of being a pure object of enjoyment. In other words, an object that, strictly speaking, is useless. Most objects of enjoyment are not pure: we are only partially satisfied, and soon we want more. We get back into the network of tradable goods and waste. But with an object that can't be sold, we are in another register.

There were various rumours, indeed, that the thief had established Leonardo's painting in a Paris apartment just like a mistress, passing his hours in the rapture of contemplation. Beyond the tension between use and enjoyment, the theft thus tapped into another powerful cultural myth: that of the lover transfixed by a lifeless image. Such stories abound in classical literature, and continue up to the modern versions of *Pygmalion*. A painting or statue goes into the place of a lost love object, and freezes it, so that the lover pines away in front of cold canvas or stone. The way in which these tales focus on the sickness of love brings out the absolute nature of its object: it is unexchangeable, unreplaceable and thus, in a sense, inhuman. Blind, passionate,

unerring love always seems to have something of the inhuman about it: whatever the object says or does, the lover is still obsessed.

The *Mona Lisa* was perfectly suited to slide into this niche that mythology and literature had been preparing for it for centuries. Its status as an icon only added to the conviction that the painting could not circulate, like other stolen goods, to give it an absolute value. And hence, despite the presence of the enormous, crystal-clear fingerprint left at the crime scene, no one bothered with Peruggia's prints. If they were looking for a millionaire, how could they have come up with a house painter?

After Peruggia's apprehension, the director of the museum's investigations was candid enough to declare that it had never crossed his mind that the thief could have been someone so modest. And Peruggia himself, explaining the fiasco of incompetence around him, reasoned that it just hadn't occurred to anyone that such a feat could have been executed by a 'poor devil' such as himself. Indeed, in the most extended discussion of the theft to have seen print, Seymour Reit's book *The Day They Stole the Mona Lisa*, the reader familiar with Peruggia's story might be bewildered to find the culprit described on the first page as 'an elegant gentleman of impeccable dress and manner'. Could even the most exalted flight of fancy transform the poor house painter into this figure of sophistication?

We learn soon enough that the description applies, in fact, to an Argentinian mastermind, the sinister and brilliant brain behind an operation carried out by 'a stupid carpenter and his two dull assistants'. Unable to accept the basic and unpalatable facts of the case – that a great art theft could be perpetrated by what he chooses to call a 'stupid carpenter' –

the author is compelled to make of him merely a pawn, in a plot 'structured with the symmetry and precision of a Bach fugue'. The incompetence of the investigators is even explained with the hypothesis of an undercover agent working in the police department. Such speculations testify to the power of the *Mona Lisa*'s logic: stealing her turns you into someone else.

The key lies in this discrepancy between the sophisticate and the 'poor devil'. The absolute nature of the purloined object put it beyond the register of exchangeable goods, and hence the thief had to be someone who already had a great deal, if not everything. If the object stolen had been some lesser relic, wouldn't the police have found their man sooner? An idea about Art with a capital 'A' and its appreciation functioned here to stop them from seeing.

The only one to get it right turned out to be a dog called Pilu. When *Le Matin* appealed to France's spiritualists for help in recovering the missing painting, the exactitude of their replies must have impressed. The ghost of Leonardo himself chimed in, explaining that the *Mona Lisa* could be found at the home of a Mr Tosmer, at 42 Rennor Street, New York. More modest voices claimed Amsterdam Street in London, or, less helpfully, a garage situated somewhere between Courbevoie and Becon-les-Bruyères. According to a Monsieur Bourlingot, there was no doubt about the matter at all: send the reward money immediately, he told *Le Matin*, since you'll find the *Mona Lisa* at the home of a soft-drinks manufacturer in Monlargis, nickname supplied. When Pilu's master, a Monsieur Ancillotti, appealed to him as he was wont to do when it came to questions of gravity, all the dog would say was that the *Mona Lisa* was still in Paris. Nothing more, nothing less. And, as history shows, Pilu's minimal response was correct.

Aside from their skewed preconceptions as to the culprit's station, another factor that slowed the detectives down was the fact that their search involved a missing woman. Where scholars had spent years debating the nature and meaning of the *Mona Lisa* smile, it was now less a question of asking, 'Why is she smiling?' than 'Where is she?' The enigma of femininity embodied by the painting had become the enigma of a missing person: and, indeed, many of the contemporary cartoons show Leonardo's model cavorting around Paris, enjoying her newfound liberty. She had stepped out of the frame that scholars and art lovers had built for her, leaving them with only an empty space. Despite the fact that the *Mona Lisa*'s image graced the covers of most of the tabloids, the Police Department still found it necessary to distribute 6,500 photographic reproductions in the *Bulletin de police criminelle*. One could project the alternative scenario in which, to clear up the older mystery, they had distributed 6,500 reproductions not of the portrait in its entirety but simply of its smile.

When the troops of policemen descended on the Minister's apartments in Edgar Allan Poe's story *The Purloined Letter*, their meticulous search proved fruitless. The Minister has in his possession a compromising letter, which he has stolen from the Queen. It is only the Parisian sleuth Dupin who has the wits to find it: not hidden or concealed, but in full view, lying innocently in a card rack on the mantelpiece. It was the letter's transparency that made it invisible. While everyone was searching for something hidden, it was Dupin who understood that the best place to hide a letter is exactly where no one will look for it: that is, in the least hidden of places. As Freud's theories suggest, we look only for what is *hidden* in our visual reality. Otherwise, we see nothing.

In his long commentary on Poe's story, Lacan explored the relations between the central characters and the interplay of looks that characterizes the action. When the Minister first sees the letter to the Queen, he notices it lying unconcealed on a table, and takes advantage of the presence of the unsuspecting King to steal it quite openly. He leaves a substitute letter in its place, just as Dupin does when he succeeds in purloining the original letter from the Minister later on. Lacan thought that possession of the letter had a feminizing effect on the various characters, but one could also argue that the maverick detective was able to find the letter because he occupied a feminine position himself, in the same way that the Minister could pinpoint it in the first place due to his looking from the place of the Queen. Where the policemen found nothing, Dupin's feminine eye knew exactly where to look.

If we compare Poe's narrative with the saga of the *Mona Lisa*, we find a strange echo in this tension between male and female gaze. The popular press expressed their amazement that none of the Louvre's many guards had become suspicious at the sight of a man leaving with an obviously bulky object beneath his smock. And yet, when Peruggia unveiled the *Mona Lisa* to his startled guests in his hotel room two years later and agreed to take it with them to the Uffizi for verification, he had got no further than the hotel door when the concierge stopped him. He might have been able to walk out of the Louvre with his purloined object, but not the Tripoli-Italia Hotel. It was only after they had convinced the concierge that they were not in the process of abstracting one of the hotel room's chintzy reproductions that they could leave in peace.

❧

Peruggia's relation to art was not to end with the *Mona Lisa* affair. After his prison sentence and a spell in his home town in Italy, he moved back to France and, with his wife, opened a paint and varnish store in Haute-Savoie. This generous gesture invites interpretation: did he do it to make reparation for the harm done to the world of art or as a front for a ring of art forgers? Whatever the reason, it could not have proven an entirely successful venture, as before long he was selling new versions of his story to the French tabloids. After this, we don't know too much about him. But perhaps, as he slid into anonymity, he continued to supply those who would make their mark on the history of modern art.

What about the poor *Mona Lisa* herself? When she got back to the Louvre, the pomp and ceremony of her reception was not enough to silence a few dissenting voices. For some, this was a copy and not the real thing. For others, there was no doubt that she was real, but since it had been mostly thanks to the cracks on the back of the panel that her authenticity had been guaranteed, it was proposed that she be hung with her face to the wall. And her smile was now interpreted less as the enigmatic emblem of femininity than as a sign of bemusement at all the dumb things that had been said about her during her absence.

Before coming home, the *Mona Lisa* travelled around in Italy, and then, after enough time to rehabituate to the Louvre, she saw the States and Japan, all with crowds to match her newfound celebrity. Although there are earlier examples of huge crowds converging to view some work of art, it is surely the returned *Mona Lisa* that heralds this distinctly modern phenomenon of thousands trooping in front of a picture. And also, perhaps, the distinctly modern phenomenon of counting them. The contemporary accounts

are filled with figures quantifying the love of art, as if the pricelessness of the work could be somehow converted into viewing figures: if you can't say how many dollars the *Mona Lisa* is worth, you *can* say how many punters went to see her in a set time.

In the States, when the painting went on loan to New York, visitors were allowed a maximum of three minutes in her presence. If that seems unfair, in Japan her worshippers were given an amazing ten seconds. Just enough time to take a photograph, but certainly not enough time to steal it. Perhaps it is from this moment that the Japanese date their passion for photographing the objects of tourism. But what, after all, could give Leonardo's masterpiece its status back as a painting and not simply as a symbol of art? Could anything more effective happen than its abstraction?

It may not be an accident that the most recent solution was proposed and then funded by the Japanese. In the largest cultural bequest that the Louvre has ever received from a foreign country, a special room will be built to house the *Mona Lisa*, designed specifically to maximize the viewer's appreciation and focus. Commenting on this initiative, *The Times* could say that 'precisely because the picture has become overfamiliar, it demands more time rather than less to be understood. It asks to be seen with a refreshed eye.' The construction of a special room supposedly responds to these requirements, and we can note that the revitalization of Leonardo's painting now depends not on a subtraction but on an addition, a supplement that would seem to be the very opposite of a theft.

But isn't there a dimension of theft always present in art? An object is taken out of the world, and acquires a new resonance: it could be a urinal or some bricks, as in modern

art, or it could be a narrative painting, as in classical art, where the world it is taken out of is that of previous narrative painting. But the key is that it finds itself in a new place. By moving the *Mona Lisa* from its present location in the Louvre to a new and specially fashioned enclosure, isn't the same principle at work? Although the theft of the painting brought out the split between the work of art and the empty space it inhabited so forcefully, the more modest gesture of rehousing it still evokes the question of place, though in a gentler, less brutal way.

At which point the reader might ask whether the logic of absence we have made so much of in this book would imply that viewers congregate not only around the newly rehoused painting but also around the space it once inhabited. Would the crowds flock once again to see the absence of a painting, as they had in 1911? The negative response to this question shows us how a real disappearance is different from a displacement. This is not to say that the most effective museum or gallery is an empty one. Emptiness, as we've seen, has to be created. Lamenting the state of the Louvre after the *Mona Lisa*'s disappearance, *Le Figaro* said that the museum should be a kind of dictionary, easy to consult and with each object remaining in exactly the same place.

Logically, it makes little sense to speak of an absence without a system that assigns places to different things, be it a dictionary or a library. And hence it may be less the empty museum that matters than the museum with one thing missing, one empty place created in its dense network of artefacts. The story of the vanishing of the *Mona Lisa* has shown us what happens when the split between the artwork and the empty place it occupies is made manifest. But there is still enough of this empty space present when art fails to

disappear: it is the special, sacred space that the artwork inhabits, the space that makes us ask the question, 'Is this art?' The problem, and the power, of this space is that we can't see it. Art can evoke it for us, but it remains invisible. It is both what art invites us to see and what art stops us from seeing.

NOTES

page

1 For details of the theft, I have relied on the following contemporary sources: *Le Temps, L'Intransigeant, Paris-Journal, L'Humanité, Le Figaro, L'Echo de Paris, L'Illustration, Le Matin, Le Petit Parisien*. See also Roy McMullen, *Mona Lisa, The Picture and the Myth* (Boston, Houghton Mifflin, 1975); Jérôme Coignard, *On a volé la Joconde* (Paris, Adam Biro, 1990); Anne Manson, 'Le Vol de *la Joconde*', in Gilbert Guilleminault (ed.), *Le Roman vrai de la IIIième et de la IVième République*, vol. 1 (Paris, Laffont, 1957; 1991 edn), pp. 921–41, and Milton Esterow, *The Art Stealers* (New York, 1966).

2 Franz Kafka, *Reisetagebucher in der Fassung der Handschrift* (Frankfurt, Fischer, 1994), p. 67, and Max Brod–Franz Kafka, *Eine Freundschaft* (Frankfurt, Fischer, 1987), pp. 212–13.

5 *New York Times*, 10 January 1963, p. 7, and 5 March 1963, p. 8. On the history of 'blockbuster' shows, see Francis Haskell, *The Ephemeral Museum, Old Master Paintings and the Rise of the Art Exhibition* (Yale University Press, 2000).

6 On Herring, see Janet Ulph, 'Tracing and recovering stolen art or the proceeds of sale', in Norman Palmer (ed.), *The Recovery of Stolen Art* (London, Kluwer Law International, 1998), pp. 67–108.

7 Freud, 'Leonardo Da Vinci and A Memory of his Childhood', standard edn of *The Complete Psychological Works of Sigmund Freud* (SE), vol. XI (London, Hogarth Press, 1957), pp. 63–137.

10 On children's art, see Maureen Cox, *Children's Drawings* (London, Penguin, 1992), and Karen Vibeke Mortensen, *Form and Content in Children's Figure Drawings* (New York University Press, 1991).

11 Freud on scopophilia, *Three Essays on the Theory of Sexuality*, SE, vol. VII, p. 156.

12 Jerry Gorovoy and Pandora Tabatabai Asbaghi, *Louise Bourgeois: Blue Days and Pink Nights* (Milan, Prada Foundation, 1997). Leo Steinberg, *The Sexuality of Christ in*

Renaissance Art and in Modern Oblivion (New York, Pantheon, 1989).

13 'The Scoptophilic Instinct and Identification' (1935), in *The Collected Papers of Otto Fenichel*, vol. 1 (New York, Norton, 1953), pp. 373–97.

14 M. Scaife and J. Bruner, 'The capacity for joint visual attention in the infant', *Nature*, 253 (1975), pp. 265–6, and Daniel Stern, *The First Relationship: Infant and Mother* (Harvard University Press, 1977). Jacques Lacan, *The Four Fundamental Concepts of Psychoanalysis*, translated by Alan Sheridan (London, Penguin, 1979).

15 On court spectacle, see Roy Strong, *Splendour at Court* (London, Weidenfeld and Nicolson, 1973). Jean Piaget, *Les Explications causales* (Paris, Presses Universitaires de France, 1971).

17 Ernst Gombrich, *Art and Illusion*, 2nd edn (London, Phaidon, 1962), p. 234.

18 On targeting the eyes, see Dario Gamboni, *The Destruction of Art: Iconoclasm and Vandalism since the French Revolution* (London, Reaktion Books, 1997). On theories of light, see David Lindberg, *Theories of Vision from Al-Kindi to Kepler* (University of Chicago Press, 1976); Gérard Simon, *Le Regard, l'être et l'apparence dans l'optique de l'antiquité* (Paris, Seuil, 1988); A. Mark Smith, 'Getting the Big Picture in Perspectivist Optics', *Isis*, 72 (1981), pp. 568–89. For Leonardo's views on the optical pyramid, see Martin Kemp, 'Leonardo and the Visual Pyramid', *Journal of the Warburg and Courtauld Institutes*, 1977, pp. 128–49. Gerald A. Winer et al., 'Conditions affecting beliefs about visual perception among children and adults', *Journal of Experimental Child Psychology*, 61 (1996), pp. 93–115.

20 For Descartes and geometry, see Aurora Plomer, *Phenomenology, Geometry and Vision* (Aldershot, Avebury, 1991).

21 On the camera obscura, see bibliography in Darian Leader, *Freud's Footnotes* (London, Faber and Faber, 2000), p. 52, n. 1.

22 On mimicry, see Roger Caillois, *Le Mythe et l'homme* (Paris, Gallimard, 1938), and Mary Alice Evans, 'Mimicry and the Darwinian Heritage', *Journal of the History of Ideas*, 1965, pp. 211–20.

24 Jacques Lacan, 'The mirror phase as formative of the function of I as revealed in psychoanalytic experience' (1949), in *Ecrits:*

A Selection, translated by Alan Sheridan (New York, Norton, 1977). On imitation: see A. N. Meltzoff and M. K. Moore, 'Newborn infants imitate adult facial gestures', *Child Development*, 54 (1983), pp. 702–9.

26 Shelley Rohde, *L. S. Lowry, A Biography*, 3rd edn (Salford, The Lowry Press, 1999), p. 212.

29 Lillian Schwartz, 'The Art Historian's Computer', *Scientific American*, 272 (April 1995), pp. 80–85. Bradley Collins, *Leonardo, Psychoanalysis, and Art History* (Evanston, Illinois, Northwestern University Press, 1997). Martin Kemp (ed.), *Leonardo on Painting* (Yale University Press, 1989), p. 204.

30 S. J. Freedberg, *Painting of the High Renaissance in Rome and Florence* (Harvard University Press, 1961), p. 335.

31 Lacan, *The Four Fundamental Concepts*, op. cit., p. 107.

33 Slavoj Žižek, *Looking Awry, An Introduction to Lacan through Popular Culture* (Cambridge, Mass., MIT, 1992).

36 On Lowry, see Rohde, *L. S. Lowry, A Biography*, op. cit., and Michael Howard, *Lowry, A Visionary Artist* (Salford, The Lowry Press, 2000).

38 Richard Gombrich, 'The Consecration of a Buddhist Image', *Journal of Asian Studies*, 26 (November 1966), p. 25.

39 On dropping objects, see Walter Burkert, *Creation of the Sacred, Tracks of Biology in Early Religions* (Harvard University Press, 1996).

41 André Malraux, *Picasso's Mask* (1974) (New York, Da Capo Press, 1994), and Mary Gedo, *Picasso, Art as Autobiography* (University of Chicago Press, 1980).

43 David Sylvester, *The Brutality of Fact, Interviews with Francis Bacon*, 3rd edn (London, Thames and Hudson, 1987). *The Letters of Thomas Gainsborough*, edited by Mary Woodall (Cupid Press, 1961), p. 99.

45 On Klee, see Ernest Harms, 'Paul Klee as I Remember Him', *Art Journal*, 32 (1972–73), p. 178.

46 Rosenberg on Warhol, 'The Art World', *The New Yorker*, 12 June 1971.

47 D. R. Dendy, *The Use of Lights in Christian Worship* (London, SPCK, 1959). On Islamic designs, see Oleg Graber, *The Mediation of Ornament* (Princeton University Press, 1992).

48 On attention to work, see M. H. Abrams, 'Kant and the Theology of Art', *Notre Dame English Journal*, 13 (1981),

pp. 75–106, and Hans Belting, *Likeness and Presence: A History of the Image before the Era of Art* (Chicago University Press, 1994).

50 Andrew McClellan, *Reinventing the Louvre* (Cambridge University Press, 1994).

51 Burkert, *Creation of the Sacred*, op. cit. On sacrifice, see Walter Burkert, *Homo Necans* (Berkeley, University of California Press, 1983), and M. F. C. Boudillon and Meyer Fortes (eds), *Sacrifice* (London, Academic Press, 1980).

52 On burial, see G. Luquet, *Art and Religion* (Yale University Press, 1930), and L. V. Grinsell, *Barrow, Pyramid and Tomb, Ancient Burial Customs in Egypt, the Mediterranean and the British Isles* (London, Thames and Hudson, 1975). On haunted portraits, see Theodore Ziolkowski, *Disenchanted Images, A Literary Iconology* (Princeton University Press, 1977).

53 George Boas, 'The *Mona Lisa* in the History of Taste', *Journal of the History of Ideas*, 2 (1940), pp. 207–24.

55 Freud on drives, see *Three Essays on the Theory of Sexuality*, op. cit, and 'Instincts and their Vicissitudes' (1915), SE, vol. XIV, pp. 117–40.

56 Groucho Marx, *Beds* (1930) (Indianapolis, Bobbs-Merrill, 1976).

57 On Kinsey, see Mary Jane Sherfey, *The Nature and Evolution of Female Sexuality* (New York, Random House, 1972).

58 Jacques Lacan, *The Ethics of Psychoanalysis*, seminar of 1959–60, edited by J.-A. Miller, translated by Russell Grigg (New York, Norton, 1992).

62 Denis de Rougemont, *Love in the Western World* (New York, Pantheon, 1956).

64 Klein and Lacan use Ruth Weber's married name, Kjär. Melanie Klein's paper is 'Infantile Anxiety Situations Reflected in a Work of Art and in the Creative Impulse' (1929), in *Love, Guilt and Reparation* (London, Hogarth Press, 1975), pp. 210–18.

66 Karin Michaelis, 'Ruth Kjär', in *Flammende Tage, Gestalten und Fragen zur Gemeinschaft der Geschlechter* (Dresden, 1929), pp. 200–206.

67 On empty space, *Le Matin*, 30 August 1911. *Le Figaro*, 5 January 1914. Francis Steegmuler, *Apollinaire among the Painters* (New York, Farrar, Straus and Giroux, 1963), and J. J. Sweeney, 'Picasso and Iberian Sculpture', *Art Bulletin*, September 1941, pp.191–8.

69 Gertrude Stein, *Picasso* (London, Batsford, 1938). On the *Mona Lisa*'s new status, see Coignard, *On a volé la Joconde*, op. cit., and the extensive discussion in Hans Belting, *The Invisible Masterpiece* (London, Reaktion Books, 2001).

70 On Pliny, see H. van de Waal, 'The *Linea Summae Tenuitatis* of Apelles: Pliny's Phrase and its Interpreters', *Zeitschrift für Asthetik und Allgemeine Kunstwissenschaft*, 1967, 12, pp. 5–32.

72 Wu Hung, *The Double Screen* (London, Reaktion Books, 1996).

73 On archaic art, see Luquet, *Art and Religion*, op. cit.; Lacan, 'Identification', unpublished seminar, 1961–62, and Whitney Davis, *Replications: Archeology, Art History, Psychoanalysis* (Pennsylvania University Press, 1996).

75 On shadows, Robert Rosenblum, 'The Origin of Painting: A Problem in the Iconography of Romantic Classicism', *Art Bulletin*, 34 (1957), pp. 279–90.

76 On Malevich, see Gerard Wajcman, *L'objet du siècle* (Paris, Verdier, 1998), and John Golding, 'The Black Square', *Studio International*, 189 (March/April 1975), pp. 96–106. Slavoj Žižek, *The Fragile Absolute* (London, Verso, 2000).

77 On landscape, see Ernst Gombrich, 'The Renaissance Theory of Art and the Rise of Landscape', in *Norm and Form* (London, Phaidon, 1966), pp. 107–21, and Christopher Wood, *Albrecht Altdorfer and the Origins of Landscape* (University of Chicago Press, 1993). On composition, see Jeroen Stumpel, 'On Grounds and Backgrounds. Some Remarks about Composition in Renaiassance Painting', *Simiolus*, 18 (1988), pp. 219–43, 'Perspective's Veil' (unpublished), and Thomas Puttfarken, *The Discovery of Pictorial Composition, Theories of Visual Order in Painting* 1400–1800 (Yale University Press, 2000). On the *Mona Lisa* landscape, see Webster Smith, 'Observations on the Mona Lisa Landscape', *Art Bulletin*, June 1985, pp. 183–99.

82 Ernst Gombrich on half-seeing, *Art and Illusion*, op. cit., pp. 177–9.

84 On jokes, see Ernst Gombrich, 'Freud's Aesthetics' (1966), in Richard Woodfield (ed.), *Reflections on the History of Art* (Oxford, Phaidon, 1987), pp. 221–39, and Jacques Lacan, *Les Formations de l'inconscient*, seminar of 1957–58, edited by J.-A. Miller (Paris, Seuil, 1998).

86 Martin Kippenberger, *I Had a Vision* (San Francisco Museum of Modern Art, 1991).

90 Jean Piaget, 'The Child and Modern Physics', *Scientific American*, 196 (March 1957), pp. 46–51.

91 On de Kooning, see Harold Rosenberg, *The Anxious Object* (University of Chicago Press, 1966), p. 120.

96 On Picasso and Braque, see William Rubin, *Picasso and Braque: Pioneering Cubism* (Museum of Modern Art, New York, 1989). Leo Steinberg, 'The Algerian Women and Picasso at large', in *Other Criteria* (Oxford University Press, 1972), pp. 125–234.

97 Gedo, *Picasso, Art as Autobiography*, op. cit., p. 85. W. Boeck and J. Sabartès, *Picasso* (London, Thames and Hudson, 1955), p. 25.

99 W. H. D. Rouse, 'The Two Burials in Antigone', *Classical Review*, 25 (1911), pp. 40–42, and S. M. Adams, 'The Burial of Polyneices', *Classical Review*, 45 (1931), pp. 110–11.

100 *Minutes of the Vienna Psychoanalytic Society*, vol. 2, edited by Herman Nunberg and Ernst Federn (New York, IUP, 1967), pp. 338–52.

101 Jacques Lacan, *Ecrits* (Paris, Seuil, 1966), p. 712.

102 Gerhard May, *Creatio Ex Nihilo, The Doctrine of Creation out of Nothing in Early Christian Thought* (Edinburgh, T. & T. Clark, 1994). Lacan's reference is probably Alexandre Koyré, *From the Closed World to the Infinite Universe* (Baltimore, Johns Hopkins University Press, 1957). On *Tsimtsum*, see Gershom Scholem, *The Kabbalah and its Symbolism* (1960) (London, Routledge and Kegan Paul, 1965), pp. 100–116, and *Major Trends in Jewish Mysticism* (New York, Shocken, 1946), pp. 260–61.

106 Gombrich on food, *Tributes: Interpreters of our Cultural Tradition* (Cornell University Press, 1984), p. 63.

107 Jean Bazaine, *Notes sur la peinture* (Paris, Seuil, 1953).

108 *The Times*, 23 August 1911. Etienne Gilson, *Painting and Reality* (1957), 2nd edn (Princeton University Press, 1968), p. 259.

109 *Harvard Educational Review*, 37 (1967), pp. 250–63.

110 Claude Lévi-Strauss, 'Split Representation in the Art of Asia and America' (1944–45), in *Structural Anthropology* (New York, Basic Books, 1963), pp. 245–68.

112 Harold Rosenberg, 'The Art World', *New Yorker*, 24 July 1971.

113 Freud, *Moses and Monotheism*, SE, vol. XXIII, pp. 111–15.

115 Freud, letter to Jung of 10 January 1912, and Michel Silvestre,

'Mise en cause de la sublimation' (1979), in *Demain la psychanalyse* (Paris, Navarin, 1987), pp. 178–99. Freud, *The Ego and Id*, SE, vol. XIX, pp. 54–6.

116 James Elkins, *What Painting Is* (New York, Routledge, 2000).

118 On Duchamp, see Calvin Tomkins, *Duchamp, A Biography* (London, Chatto, 1997), the interview with François Le Lionnais, 'Marcel Duchamp as a chess player and one or two related matters', *Studio International*, January/February 1975, pp. 23–5, and Pierre Cabanne, *Dialogues with Marcel Duchamp* (New York, Da Capo, 1979), pp. 70 and 77.

120 Lucian Freud, 'Some thoughts on painting', *Encounter*, vol. 3, July 1954, pp. 23–4.

121 On spiders, see Ernst Kris and Otto Kurz, *Legend, Myth and Magic in the Image of the Artist* (1934) (Yale University Press, 1979), p. 65, and Thomas DaCosta Kaufmann, *The Mastery of Nature: Aspects of Art, Science and Humanism in the Renaissance* (Princeton University Press, 1993).

122 Eva Hesse, 'Untitled Statement' (1968), in K. Stiles and P. Selz (eds), *Contemporary Art, A Sourcebook of Artists' Writings* (Berkeley, University of California Press, 1996).

123 Brian Ashbee, 'Art Bollocks', *Art Review*, April 1999, pp. 51–3.

124 Freud, *Screen Memories* (1899), SE, vol. III, pp. 303–22.

125 On beauty, see A. N. Michelini, *Euripides and the Tragic Tradition* (University of Wisconsin Press, 1987). On Lacan's reading of *Antigone*, see Jean Bollack, *La Mort d'Antigone, La Tragédie de Créon* (Paris, Presses Universitaires de France, 1999).

128 Albert Elsen, *The Partial Figure in Modern Sculpture* (Baltimore Museum of Art, 1969). Leo Steinberg, 'Michelangelo's Florentine *Pietà*: The Missing Leg', *Art Bulletin*, 1968, pp. 343–53.

129 Eric Rothstein, 'Ideal Presence and *Non Finito* in Eighteenth Century Aesthetics', *Eighteenth Century Studies*, 1976, pp. 307–32.

130 On perspective, see Jeroen Stumpel, 'On Grounds and Backgrounds', op. cit.; Thomas Puttfarken, *The Discovery of Pictorial Composition*, op. cit.; Stumpel, 'Perspective's Veil' (unpublished); Martin Kemp, *The Science of Art, Optical Themes in Western Art from Brunelleschi to Seurat* (Yale University Press, 1990); James Elkins, *The Poetics of Perspective* (Cornell University Press, 1994); Michael Kubovy, *The Psychology of Perspective and Renaissance Art* (Cambridge University

Press, 1986), and William Dunning, *Changing Images of Pictorial Space, A History of Spatial Illusion in Painting* (Syracuse University Press, 1991). The avoidance of linear perspective in non-Western traditions is arguably a non-question: see Puttfarken, *The Discovery of Pictorial Composition*, p. 73.

133 This aspect of Greenberg was famously – and rather unfairly – satirized by Tom Wolfe in *The Painted Word* (New York, Farrar, Straus and Giroux, 1975).

134 On looks inscribed into pictures, see Svetlana Alpers, *The Art of Describing* (University of Chicago Press, 1983).

135 Lacan, *The Four Fundamental Concepts*, op. cit., and Jurgis Baltrusaitis, *Anamorphic Art* (1955) (Cambridge, Chadwyck-Healey, 1977); Kim Veltman, 'Perspective, Anamorphosis and Vision', *Marburger Jahrbuch für Kunstwissenschaft*, 1986, pp. 93–117, and Mary Hervey, *Holbein's Ambassadors* (London, 1900). A controversy over the skull takes place in *The Times*, London, 20 October 1997, and then letters of 25 October and 1 November 1997.

137 On Descartes, see Baltrusaitis, *Anamorphic Art*, op. cit., and P. J. S. Whitmore, *The Order of the Minims in Seventeenth-Century France* (The Hague, 1967).

139 On Byzantine art, see Otto Demus, *Byzantine Mosaic Decoration* (London, Routledge and Kegan Paul, 1948).

141 On depicting the eye, see Gerald Eager, 'The Missing and the Mutilated Eye in Contemporary Art', *Journal of Aesthetics and Art Criticism*, 1961, pp. 49–59.

143 Matthew Dickie, 'The Fathers of the Church and the Evil Eye', in Henry Maguire (ed.), *Byzantine Magic* (Harvard University Press, 1995), pp. 17–34.

146 Olivier Richon, *Allégories* (Valenciennes, L'Aquarium Agnostique, 2000).

147 On Bacon, see David Sylvester, *The Brutality of Fact*, op. cit.; Hugh Davies, *Francis Bacon: The Early and Middle Years, 1928–1958* (New York, Garland, 1978); Daniel Farson, *The Gilded Gutter Life of Francis Bacon* (London, Century, 1993), and Michael Peppiat, *Francis Bacon: Anatomy of an Enigma* (London, Weidenfeld and Nicolson, 1996).

153 Jean-Paul Sartre, *Being and Nothingness* (1943), translated by Hazel Barnes (London, Methuen, 1958), part 3, chapter 1, section 4. On an analogous shift in register in religious dis-

course, see David Chidester, *Word and Light* (University of Illinois Press, 1992).

154 On *Mona Lisa*'s smile, see Collins, *Leonardo*, op. cit.; Boas, 'The *Mona Lisa* in the History of Taste', op. cit., and A. Richard Turner, *Inventing Leonardo, The Anatomy of a Legend* (New York, Knopf, 1993).

156 Kenneth Clark, *Leonardo da Vinci*, edited by Martin Kemp (Harmondsworth, Penguin, 1989). Vasari, *Lives of the Artists* (Harmondsworth, Penguin, 1965), p. 259.

158 Carlo Pedretti, 'The Angel in the Flesh', *Achademia Leonardi Vinci*, 4 (1991), pp. 34–50.

160 Gorovoy and Asbaghi, *Louise Bourgeois*, op. cit.

161 Jean Piaget and B. Inhelder, *The Child's Conception of Space* (London, Routledge and Kegan Paul, 1956), and research conducted by Martin Hughes, reported in Margaret Donaldson, *Children's Minds* (London, Fontana, 1978).

162 Harold Rosenberg on Matisse, 'The Art World', *The New Yorker*, 12 June 1971.

166 Henry Rhodes, *Alphonse Bertillon, Father of Scientific Detection* (London, George Harrap and Co., 1956).

170 Seymour Reit, *The Day they Stole the Mona Lisa* (London, Robert Hale, 1981).

172 On the Mona Lisa's cavorting, see André Chastel, *L'Illustre incomprise. Mona Lisa* (Paris, Gallimard, 1988).

173 Lacan, *Ecrits* (Paris, Seuil, 1966), pp. 11–61.

175 *The Times*, 4 April 2001.

PICTURE CREDITS

Every effort has been made to trace copyright material. In cases where this has not been possible, the publishers invite copyright holders to inform them so that due acknowledgement can be made in future printings of this book.

Printed in the United States
By Bookmasters